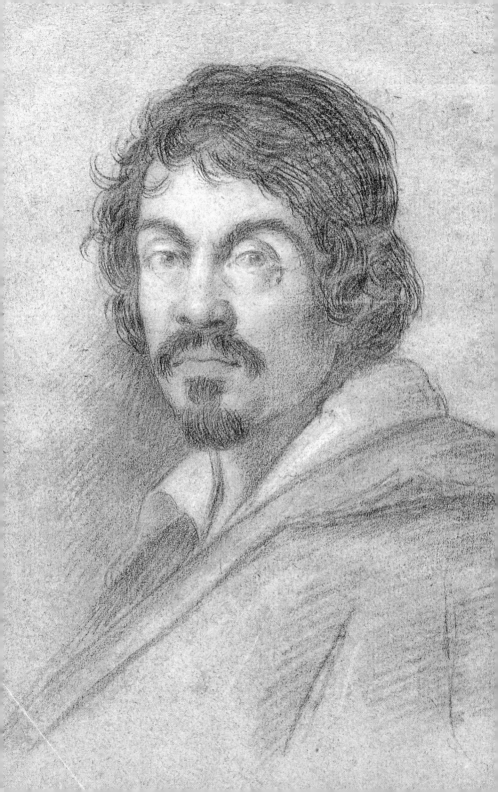

ArtBook
Caravaggio

DORLING KINDERSLEY
London • New York • Sydney • Moscow
Visit us on the World Wide Web at http://www.dk.com

Contents

How to use this book

This series presents both the life and works of each artist within the cultural, social, and political context of their time. To make the books easy to consult, they are divided into three areas, which are identifiable by side bands of different colors: yellow for the pages devoted to the life and works of the artist, light blue for the historical and cultural background, and pink for the analysis of major works. Each spread focuses on a specific theme, with an introductory text and several annotated illustrations. The index section is also illustrated and gives background information on key figures and the location of the artist's works.

PG 4+

■ p. 2: Ottavio Leoni, *Portrait of Caravaggio,* before 1650, Biblioteca Marucelliana, Florence.

1571-1592

1592-1600

8　Milan under Spanish rule
10　A young man of character
12　The painting of reality and the Lombard tradition
14　Teachers and the legendary masters of art
16　Lute Player
18　Lombard artists in Rome
20　The precursors of Caravaggio
22　Rest on the Flight into Egypt

26　A difficult environment
28　The initiatives of Pope Sixtus V
30　The last days of Mannerism
32　Boy Bitten by a Lizard
34　Naturalism
36　Large-scale works in Rome
38　Clients, collectors, and scholars
40　Prostitutes and rent-boys, gypsies and musicians
42　Boy with a Basket of Fruit
44　Origins of the still life
46　Cardinal Federico Borromeo
48　Basket of Fruit
50　Successes, replicas, copies, and variants
52　Annibale Carracci and the Farnese Gallery
54　The first great religious subjects
56　Judith Beheading Holofernes

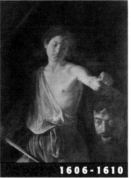

1600-1606 **1606-1610** **Index**

60 The San Luigi dei
 Francesi commission
62 The Contarelli Chapel,
 a controversial story
64 Martyrdom of St Matthew
66 Calling of
 St Matthew
68 Altar painting at the
 beginning of the
 17th century
70 Lawsuits, successes,
 and refusals
72 Rubens in Rome
74 The cycle of the
 Cerasi Chapel
76 Conversion of St Paul
78 A trip to Genoa
80 Debate on decorum
82 Madonna of the Pilgrims
84 The development
 of collections
86 The study of
 states of mind
88 St Jerome
90 The new religious orders
92 The Deposition
 of Christ
94 The first
 Caravaggisti
96 Problems of a
 violent character
98 Supper at Emmaus

102 Naples, a
 Mediterranean capital
104 Caravaggio's
 first encounter
 with Naples
106 Madonna of the Rosary
108 The Seven Works
 of Mercy
110 Malta, pride of
 the knights
112 Fame, arrest and flight
 from Valletta
114 Beheading of
 the Baptist
116 Sicilian interlude
118 Caravaggio's influence
 on the painting of
 southern Italy
120 Lost and vanished
 works, mysteries
 and surprises
122 Return to Naples
124 David with the Head
 of Goliath
126 The triumph of
 the Emilians
128 Final days
 of agony on
 the beach
130 After death: an
 example to
 European art

134 Index of places
138 Index of people

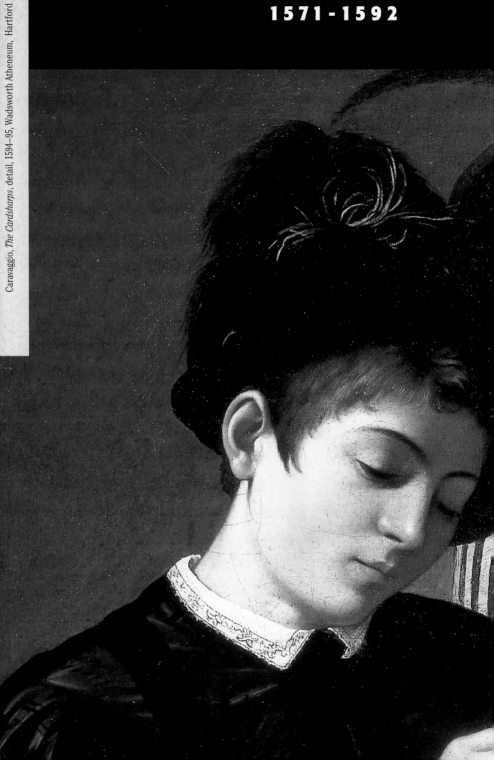

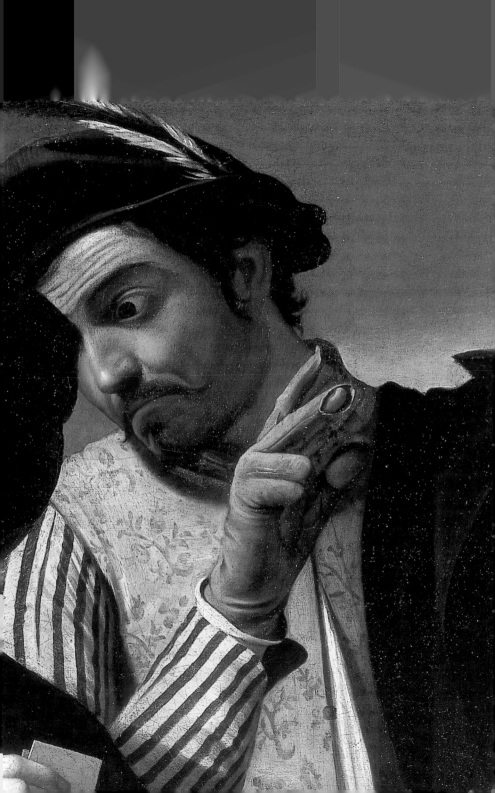

Milan under Spanish rule

■ The machine of Mount Etna with theatre and pedestals erected in the square of Milan Cathedral to celebrate the birth of the Spanish infanta, typifies the popular festivities of the 16th century.

Caravaggio's formative years were spent in Milan, a Spanish province since 1535, when Charles V of Hapsburg had occupied the city and duchy on the death without issue of Francesco Sforza. The independent state was thus gradually transformed into a vassal. With a view to reducing the risk of a measure of autonomy assuming the form of dangerous opposition, the Spanish took care to retain control of the administration, though not excluding the Milanese and Lombards from government. Furthermore, many Milanese were members of the Senate, the judicial authority that was second only to the governor. Participation in government was virtually reserved, however, for a fairly restricted elite, so that in a short time the city's patrician class was markedly strengthened, formed of ancient noble families and those who had subsequently acquired their wealth through trade. A new, aristocratic ideology took root, exemplified by much pomp and the satisfaction of honor by duelling. However, by the end of the century, for all its social and political experience, the city was in a state of economic depression. The people at large, many belonging to art and trade corporations, sought protection in the authority of the Church, principally in the powerful personalities of the bishops Carlo and Federico Borromeo. In the heyday of the Counter-Reformation, these churchmen had chosen Milan as the ideal centre from which to operate, and had transformed it into a city of prime importance in terms of political organization, social legislation, moral teaching, and religious expression.

■ Titian, *Portrait of Charles V on Horseback*, 1548, Museo del Prado, Madrid. The emperor visited Milan in 1541, using the occasion to promulgate the "New Constitution", designed to stabilize the state.

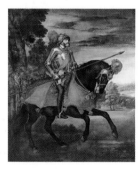

■ The castle of Milan, still known as the Porta Giovia, was fortified several times by the Spaniards, first in circular form, in 1537, and later in crescent shape, in the first half of the 17th century.

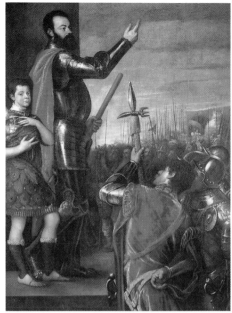

■ Sofonisba Anguissola, (attr.), *Portrait of Philip II*, Museo del Prado, Madrid. Known as the Prudent, Philip was appointed duke of Milan by Charles V in 1540, becoming king when he married Mary of England in 1554.

■ Titian, *Speech of Alfonso d'Avalos*, Museo del Prado, Madrid. Marquis of Vasto and Pescara, d'Avalos was Charles V's first governor of the state of Milan (1538–46) and is remembered as an exceptionally poor administrator.

■ *Porta Romana*, etching, 1820, Raccolta Bertarelli, Milan. The arch was built for the entry into Milan by Margaret of Austria, before her marriage to Philip III in 1598.

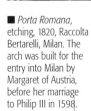

9

A young man of character

Information about the earliest years of Michelangelo Merisi is confusing and poorly documented. It is now certain that his date of birth was September 29 (the feast day of his name saint, the Archangel Michael). However, we do not know whether he was born at Caravaggio, a town in Bergamo province, from which his family originally came, or in Milan, where his father Fermo lived from 1563 to 1576. Fermo probably arrived in the capital in the wake of Francesco I Sforza, marquis of Caravaggio, his protector and employer, with whom he soon became "magister" (a vague term that indicated various activities, from artist to master-builder). Having spent his early childhood in Milan, at the age of five young Michelangelo moved with his family to Caravaggio to escape the contagion of the terrible plague of 1576. Even so, his father and grandfather both died of the disease, and documents indicate the difficulties that the artist's mother, Lucia Aratori, then faced in her efforts to maintain the family (Caravaggio had a half-sister, two brothers, and a sister) and to manage the estate; she also had arguments with her late husband's parents. These problems reached a head in 1583 with the death of the marquis of Caravaggio. Thereafter the marquisate was controlled by Costanza Colonna, and the noble Colonna family was to protect the Merisis until the end of Michelangelo's stay in Rome.

■ A hand grasping a sheaf of corn below an eagle with outspread wings is not the coat-of-arms of the Merisi, a middle-class family, but of their protectors, the marquises of the town of Caravaggio.

■ Caravaggio, *The Sacrifice of Isaac*, engraving, detail, c.1597, Galleria degli Uffizi, Florence. In one of his first works (probably dating from the 1590s), Caravaggio provides an early sample of his innovative power with this painting of a screaming Isaac.

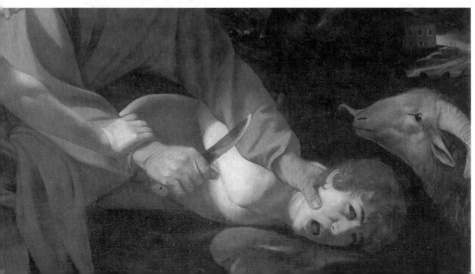

■ Frontispiece to *The Lives of the Painters, Sculptors, and Architects* by Giovanni Baglione. The Roman painter dedicated his work to Cardinal Girolamo Colonna, the "most eminent and reverend prince". The work is divided into "giornate" (working days), the fourth of which contains the life of Michelangelo Caravaggio. Although an adversary of Merisi by reason of his different artistic outlook, Baglione recognized his genius.

LE VITE
DE' PITTORI
SCVLTORI
ET ARCHITETTI.

Dal Pontificato di Gregorio XIII.
del 1572. In fino a'tempi di Papa
Vrbano Ottauo nel 1642.

SCRITTE
DA GIO. BAGLIONE ROMANO

E DEDICATE
All'Eminentissimo, e Reuerendissimo Principe

GIROLAMO
CARD. COLONNA.

IN ROMA,
Nella Stamperia d'Andrea Fei. MDCXLII.

Con licenza de'Superiori.

■ Anonymous, *Portrait of Caravaggio*, engraving, Raccolta Bertarelli, Milan. Based on a drawing by Ottavio Leoni, this represents the most faithful likeness of all those known of the painter. The serious, rather sullen expression reflects the essence of his already legendary character, which, even at a young age, was anything but straightforward.

MICHELANG.°
MERIGI
DA
CARAVAGGIO

The painting of reality and the Lombard tradition

Ⅰn the 16th century, virtually throughout Italy, the artificial style of Mannerist painting was widely acclaimed. Only in Lombardy did a more expressive form of Mannerism flourish, based on regional peculiarities that had already been evident in previous centuries. Artists endeavored to avoid stylistic compromise, preferring simplicity and attention to naturalistic detail. Obedient to tradition, they devoted themselves to the "painting of reality". Since the 15th century, several artists had been engaged in empirical research. One of them was Vincenzo Foppa, who was interested in the perception of the fluctuating effects of light and shadow. More influential still, was Leonardo da Vinci, who, venturing along diverse paths, had arrived at a representation of truth founded largely upon scientific investigation. In the 16th century, these premises came to acquire symbolic status, inspiring a challenge to conventional artistic trends, particularly in the east of the region, which, significantly, was in close contact with the culture of Venice.

■ Vincenzo Foppa, *The Miracle of Narni*, detail, Cappella Portinari, Milan. Completed in 1468, the *Stories of the Martyr St Peter* epitomize the boldest and freshest values of the Lombard tradition: naturalistic observation, strong modelling, lifelike figures, and a realistic setting.

■ Romanino, *Payment of the Laborers*, 1532, Castello del Buon Consiglio, Trento. The liveliness of the frescoed scenes derives from a rediscovered taste for narrative folklore, strongly expressive and realistic, clearly influenced by northern painting.

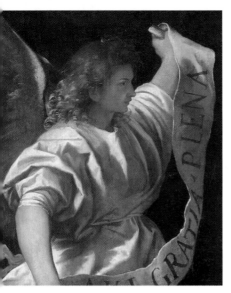

■ Titian, detail of the Angel Gabriel from the *Averoldi Poliptych*, c.1522, church of SS Nazaro e Celso, Brescia. The splendid effects of light on the figure of the angel, painted on a dark background, form a precedent to which the 16th-century Brescian painters would frequently revert.

■ Leonardo da Vinci, *The Virgin of the Rocks*, 1483–85, Musée du Louvre, Paris. This work was hung for a while in the church of San Francesco Grande in Milan, where it is possible that Caravaggio was able to admire Leonardo's studies of natural elements.

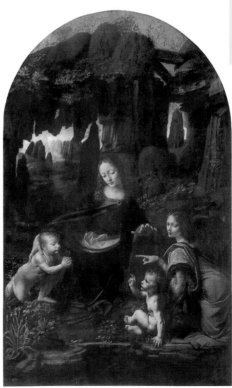

■ Moretto da Brescia, *Ravelli Altarpiece*, c.1540, Pinacoteca Tosio Martinengo, Brescia. Although the forms are monumental in the Roman figurative tradition, the characters retain a popular simplicity. Moretto's deep feeling for natural effects brings an acute sense of immediacy and truth to the pictorial representation of a sacred devotional subject, which tends to anticipate Caravaggio.

Teachers and the legendary masters of art

In 1584, Michelangelo Merisi, just 13, returned to Milan, perhaps in deference to his father's wishes, or perhaps simply with the urge to study painting. His master, Simone Peterzano, was a Bergamesque artist, probably trained in Venice, who liked to sign himself "Titiani alumnus". He was praised by his contemporary Lomazzo for his "charm and grace" – the main characteristics of his frescos – traces of which appear in the work of the young Caravaggio. Peterzano, like the Campi brothers, initially seemed drawn to the natural empiricism of Lombard tradition; yet, at the same time, he observed the canons of Mannerism with his arabesques and color contrasts, approved by Lomazzo in his *Treatise.* Moreover, Peterzano conformed to the austere Milanese style, especially in his altarpieces. These features, together with his first master's technical skills, were reflected by the young Caravaggio in his first Roman works, the *Boy Bitten by a Lizard* and the *Sick Little Bacchus*, already at marked variance with traditional painting. By now, the high season of the Renaissance was over, definitively replaced by Mannerism, most aptly summarized by Giovanni Lomazzo in the *Treatise on the Art of Painting*, published in 1584.

■ Simone Peterzano, *Venus and Cupid with Two Satyrs,* c.1573, Corsini Collection, New York. This is important for its clear Venetian influence. The varied pigmentation of the male nudes stems from a technique later learned by Caravaggio.

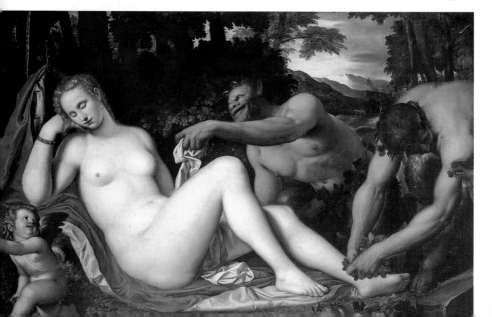

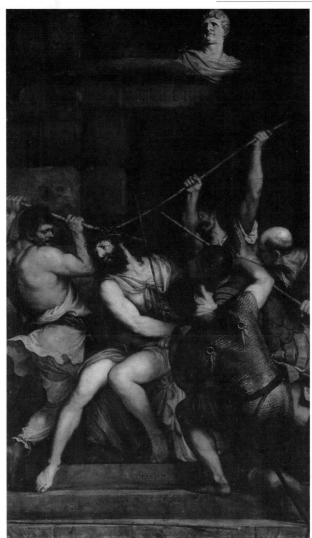

■ Anonymous, *Students in the Master's Workshop*, c.1682, engraving, Raccolta Bertarelli, Milan. On April 6, 1584, Caravaggio signed a contract with Peterzano, whereby he was to work as his apprentice for four years, living with his master, thanks to whom he would become a painter capable of doing independent work.

■ Titian, *Christ Crowned with Thorns*, 1542–44, Musée du Louvre, Paris. This was probably one of the many masterworks that Caravaggio studied during the years of his apprenticeship in Milan; it was done originally for the chapel of Santa Corona in the church of Santa Maria delle Grazie.

■ *Charterhouse of Garegnano*, engraving, c.1820, Raccolta Bertarelli, Milan. In his last great commission in Milan, Simone Peterzano carried out the frescoed decorations for the presbytery and church of the charterhouse from 1578 onward.

15

1571-1592

Lute Player

Painted for Vincenzo Giustiniani in 1596 and now in the Hermitage, St Petersburg, this is one of the most outstanding examples of Caravaggio's youthful work. With its emphasis on music, the work can be seen as a symbol of harmony.

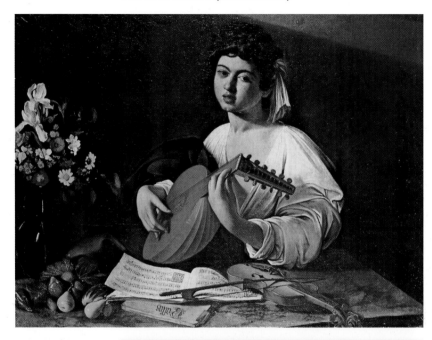

■ A second *Lute Player* (1596–97, Private Collection, New York) was painted by Caravaggio for Cardinal Del Monte. Originally conceiving this work with the same elements as the first – flowers, fruit, and musical instruments – the painter subsequently retained only the instruments in order to use the contrast between art and nature as an emblem of harmony; in place of the fruit, a spinet is substituted.

■ Caravaggio, *Concert of Youths*, detail, c.1595–96. Metropolitan Museum of Art, New York. In this first work painted for Cardinal Francesco Maria del Monte, his earliest patron in Rome and with whom he lived as a paid retainer, Caravaggio turned to the theme of music, depicting several youths singing and playing instruments. In the centre of the scene is a boy playing the lute. It may have been this work that influenced Vincenzo Giustiniani to choose the same subject.

■ *Harmony,* from the text of *Iconology* by Cesare Ripa (Rome, 1603). A woman playing a double lyre of fifteen strings, a seven-jewelled crown on her head and wearing a gown of seven colors, represents the platonic concept of the harmony of the spheres.

■ Caravaggio, *Rest on the Flight into Egypt*, detail, Galleria Doria Pamphili, Rome. Music returns in another youthful work of delicate lyricism: the angel who plays the violin, viewed from behind, reveals the score, which is the key to the understanding of the whole work.

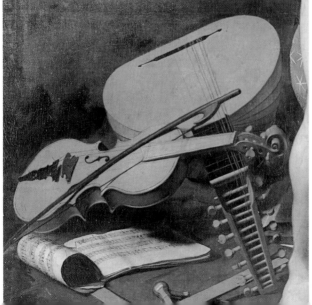

■ Musical instruments, envisaged in the form of an extraordinary still life, recur in *Victorious Cupid* (now in the Staatliche Museen, Berlin), also painted for the marquis Giustiniani.

1571-1592

Lombard artists in Rome

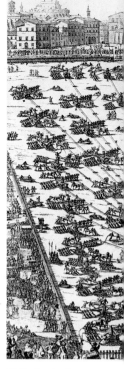

The exodus to Rome of artists from the towns and valleys of Lombardy commenced in the 15th century. Now, more than ever, Rome emerged as the great cultural centre of the peninsula, welcoming and virtually monopolizing gifted painters, sculptors, architects, and practitioners of the minor arts who set about enhancing the city's appearance. Eager and industrious, they formed a veritable colony, dedicated to the building and decoration of churches, hospitals, and palaces, gradually feeling their way towards the new period of the Baroque. Some travelled to Rome to seek their fortune, mainly through the benevolence of a pope, as in the case of Domenico Fontana, whose "Lombard manner" met with the approval of Sixtus V. The painters were not particularly innovative in their approach, for by and large they elected to adhere to the Mannerist line, nurtured on the example of the great Michelangelo, yet displaying a markedly regional emphasis. Not all of the Lombards who flocked to Rome remained there: some of them limited themselves to a brief training period or viewed their stay as an opportunity to gain artistic maturity.

■ The façade of
St Peter's basilica,
completed by Maderna
(1607–12), conforms
to Michelangelo's work
but is also receptive to
new Baroque forms.

■ Church of Santa
Maria in Vallicella.
Begun in 1576 by Matteo
Bartolini, this church was
completed by Martino
Longhi the Elder.

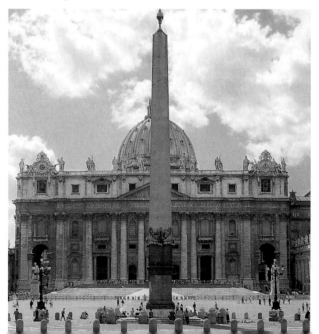

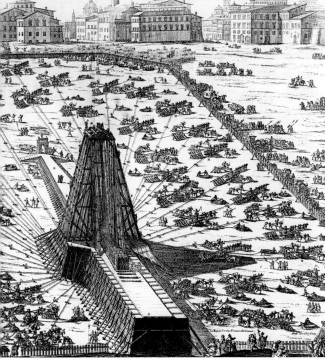

■ Pellegrino Tibaldi, *Adoration of the Shepherds,* 1549, Galleria Borghese, Rome. This is one of the most characteristic Roman works of Tibaldi, in which the painter shows that he has absorbed the teaching of Michelangelo, notably in building a composition with a crowd of figures, derived in large measure from the models of the *Last Judgement.*

■ *De translatione Obelisci Vaticani suscepta quae, prout ab eodem descriptia fuit, exibetur,* engraving, 1586, Raccolta Bertarelli, Milan. The elevation in St Peter's Square of the ancient obelisk deriving from Nero's circus was a massive undertaking, exemplifying the frenetic rebuilding activity that was then taking place in Rome. One of the architects involved in the overall project was Domenico Fontana from Lombardy.

■ Pomarancio, *Descent from the Cross,* detail, c.1585, Santa Maria in Aracoeli, Rome. The Lombard artist shows Tuscan influences that perhaps extended to Rome. In these, his loveliest frescos, he reveals a brilliant use of color that mirrors the tones of the Tuscan countryside.

The precursors of Caravaggio

Among the many questions about Caravaggio's life and work are those regarding his early training and influences. Who, in fact, was Caravaggio's true teacher, not merely in refining his technique but in encouraging his investigations into nature and light and directing him towards certain sources and subjects? During those years about which we know so little, the artist must have absorbed a taste for natural research and the pursuit of solutions that already characterized Lombard tradition. His training was founded upon Renaissance painting, in particular the work of Foppa, who was notable for his lively, realistic representation; Mantegna, master of perspective; the frescos of Giulio Romano; and the Mannerism of the Campis. It is probable that Caravaggio travelled, for instructional purposes, beyond Milan and his own neighborhood, possibly as far as Venice. He certainly became familiar with Venetian painting through the works of Brescian artists such as Moroni, Moretto, and Savoldo, whose use of color showed Venetian influence and affinities with Giorgione, Lotto, and Titian.

■ Giovanni Girolamo Savoldo, *Portrait of a Youth*, c.1524, Musée du Louvre, Paris. Here, a masterly use of chiaroscuro produces a three-dimensional effect, complemented by a shrewd handling of color in the golden scarf and folds of the materials. Such effects influenced the painting style of Caravaggio.

■ Raphael, *Liberation of St Peter*, detail, 1514, Musei Vaticani, Rome, Stanza di Eliodoro. This was an invaluable precedent for the use of light and chiaroscuro, which Caravaggio learned from Savoldo and the Campi brothers.

■ Giulio Romano, *Marriage of Amor and Psyche*, 1527–31, Palazzo Te, Mantua. Romano's inventions make use of the foreshortenings and perspective of Mantegna.

■ Caravaggio, *Ludovisi Wall Painting*, c.1597–98 This is the only mural painting by the artist; in keeping with contemporary apprenticeship practice, he was expected to master all the available painting techniques. The influence of Mantegna is unmistakable in the study of foreshortened bodies.

Caravaggio and the Brescians

The achievements of the Brescian artists, particularly Savoldo, who specialized in the study of light, were of fundamental importance to Caravaggio. Savoldo produced highly poetic effects, as in his depiction of internal light, his experiments with darkness (notably the *Nativity*, 1540, Pinacoteca Tosio Martinengo, Brescia), and his rendering of artificial light. As such, Savoldo was recognized as a precursor of Caravaggesque luminism.

21

MASTERPIECES

Rest on the Flight into Egypt

Dating from 1599 and now in the Doria Pamphili Gallery, Rome, this painting is thought to have been inspired by the Song of Songs. The musical score held by St Joseph is of Franco-Flemish origin, and includes some verses from the Bible.

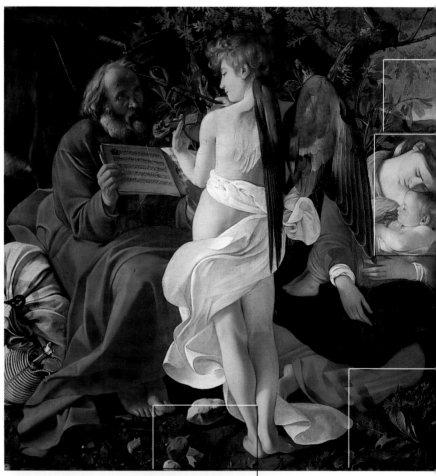

■ To the right of the angel is the Old Testament, symbolically represented by stones, dry and lifeless, and by scorched earth, reminiscent of the years of slavery in Egypt.

■ The rural landscape behind the figure of the Virgin is modelled on the Venetian treatment of this theme in sacred art. Such an open landscape is unique in Caravaggio's painting.

■ Mary is portrayed in a similar manner to the bride of the Song of Songs: her reddish hair corresponds to the verse, "The locks of thy head are like the king's purple", the color of the Redeemer's blood of salvation. Deep in slumber, cradling the infant Jesus, she recalls another verse: "I sleep but my heart is awake."

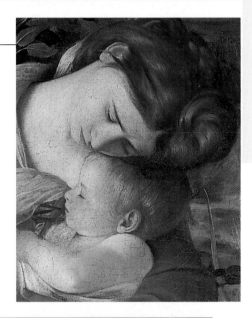

■ The plantlife at the feet of the Virgin represents one of Caravaggio's first studies of nature. An allusion to the tree of Jesse, a symbol of the promised land, may be intended.

A difficult environment

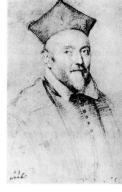

Several years after his apprenticeship to Peterzano, during which time he may have taken a trip to the eastern provinces of Lombardy or to Venice, Caravaggio travelled to Rome, where his presence is documented from 1596. Here was an artistic environment where, in the dying years of Mannerism, painters still looked back to Raphael and Michelangelo. The atmosphere was very different from that of Milan; the papal court and the cultural milieu at large were not rigidly obedient to the tenets of the Counter-Reformation (as was the case in Lombardy), but revolved around scholars and artists who embraced humanist beliefs. Caravaggio was introduced to the Cavaliere d'Arpino, Rome's leading painter, who was a "modern" artist in the tradition of the 16th-century masters, an excellent technician, and a cultured man of sharp intellect with a keen business sense. His school accommodated painters of diverse origins and talents, including foreigners such as Floris Claszoon van Dijk and Jan "Velvet" Bruegel. Caravaggio practised with classical models, learned metaphor and allegory and, at the urging of Arpino, painted a still life in competition with examples from Flanders. Although this was manual work to arouse little enthusiasm, the fusion of Lombard experience with the Roman-Flemish tradition was a first step towards further commissions.

■ Cardinal del Monte, patron of science and friend of Galileo, was a lover of music and a cultivated man of the world. He may have taught Caravaggio perspective, the projection of shadows, and the application of reason to natural data.

■ Michelangelo, *Lunette of Ezekiel*, c.1508, Cappella Sistina, Rome. The frescos of Michelangelo for the Sistine Chapel give hints of the stylistic development that was to lead to Mannerism.

■ Church of Santa Maria della Consolazione, Rome. It was probably shortly before or during his period with Arpino that Caravaggio spent time in the hospital of the Consolazione recovering from either an illness or an accident. Mancini records that the Arpino family did not even try to find out his whereabouts, which may well have soured the relationship.

■ Taddeo Zuccari, *Dance of Diana and Nymphs*, 1553, Villa Giulia, Rome. Here, Zuccari depicts orgies and mythological scenes in the Raphaelesque spirit of classicism, but with a sense of detachment for what is a now-distant world.

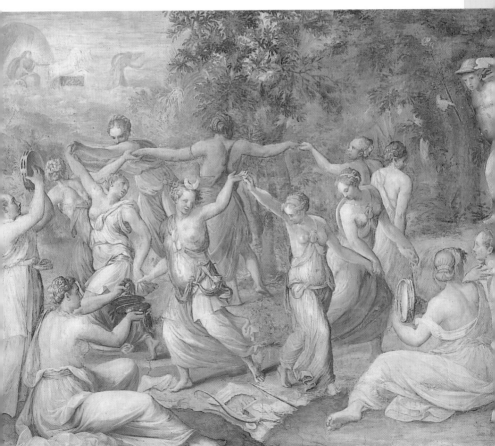

The initiatives of Pope Sixtus V

The papacy of Sixtus V saw the reconstruction of Rome, consistent with the vision of a pope who wished the city to reacquire its former political dominance. After order and calm had been restored in the Papal State with campaigns against brigandry and piracy, a programme of economic and financial restructuring paved the way for urban transformations. Thanks in large measure to Domenico Fontana, the city was embellished and modernized: the architect planned the opening of the Sistine Way and the streets that led from Santa Maria Maggiore to San Giovanni in Laterano, Santa Croce in Gerusalemme, and San Lorenzo, without eroding the existing urban fabric. At the same time, the Viminale, Esquiline, and Pincio Hill areas were replanned, with many Roman remains destroyed to furnish building materials and various ancient obelisks restored as ornaments for squares, with the addition of splendid fountains. The pope, an art lover, imposed on artists a homogeneous style of figuration that reinforced the work's overall moral purpose and exalted the historical places of worship. Consequently, during the years of his pontificate, many artists virtually adopted a common language.

■ *Piazza Navona,* etching by Israel Silvestre, 1776, Raccolta Bertarelli, Milan. Toward the end of Pope Peretti's pontificate, the Piazza Navona was transformed, becoming a splendid Baroque setting.

■ Basilica of Santa Maria Maggiore, Rome. Domenico Fontana built the Presepe Chapel inside the church, transporting an ancient lectern to stand in the new SS Sacramento Chapel, built on a central plan. In honor of the pope, he also built the Sistine Chapel.

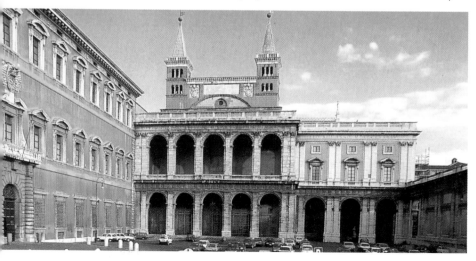

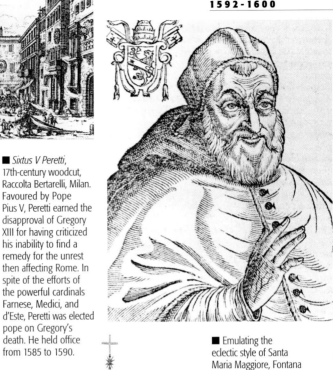

■ *Sixtus V Peretti*, 17th-century woodcut, Raccolta Bertarelli, Milan. Favoured by Pope Pius V, Peretti earned the disapproval of Gregory XIII for having criticized his inability to find a remedy for the unrest then affecting Rome. In spite of the efforts of the powerful cardinals Farnese, Medici, and d'Este, Peretti was elected pope on Gregory's death. He held office from 1585 to 1590.

■ *Arms of Sixtus V.* Below the papal tiara and keys of St Peter, the symbol of the mountain records the family origins at Montalto Marche.

■ Emulating the eclectic style of Santa Maria Maggiore, Fontana worked at San Giovanni in Laterano, building the Holy Stairs, the loggia delle Benedizioni, and the Lateran Palace.

The last days of Mannerism

■ Federico Zuccari, *The Flagellation*, c.1573, frescos in the Oratorio del Gonfalone, Rome. Zuccari developed all the potentialities of Perin del Vaga's art, culminating in the expression of the unitary form of Mannerism that took root at the end of the century.

The third and final phase of Mannerism was based on the late decorative cycles of Michelangelo and appeared in the works of painters such as Agresti, Marco Pino, and Sciolante, who had studied together with Perin del Vaga. Painting now seemed to be concentrated solely on the propagation of specific religious subjects, exploiting a language that was rigid in structure and expression, and on decorative cycles that featured fables and myths. Artists created a terminology that entailed figurative uniformity, characteristic of late Roman Mannerism, which was reassuring for painters and clients alike. An additional influence upon this language, however, was Flemish art, which, impinging for the first time on its Italian counterpart. It sought to direct the restricted range of Mannerist imagery towards new channels of originality and invention, which would, in due course, find international acceptance.

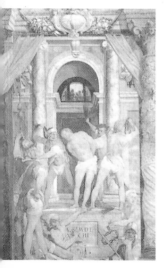

■ In the decoration of the Oratorio del Crocifisso, Rome, Cesare Nebbia gave notice of a change in the cultural climate. The ideals of the Counter-Reformation were now given a naturalistic, almost sentimental, treatment.

1592-1600

BACKGROUND

The example of Raphael and Michelangelo

In Rome, the first traces of Mannerism – highly developed in Renaissance art – were to be seen in Michelangelo and late Raphael. The works of the former were markedly anti-classical, whereas the latter, respectful of classicism, achieved a perfect synthesis of form and colour, with the most expressive results. Followers of both masters were capable of fusing and amalgamating these opposing visions, extending the long period of Mannerism and ending the confrontation between the schools of classicism and anti-classicism.

■ Among the major examples of Mannerism in Rome are the frescos of Cecchino Salviati in the Palazzo Sacchetti (1553–54): in his choice of biblical and heroic episodes, and his elegant, sophisticated compositions, the artist shows a special brand of virtuosity.

■ Raffaellino da Reggio, frescos in the church of the Santi Quattro Coronati, Rome, c.1578. With this artist, one of the most gifted of his generation, Roman Mannerism virtually ended, shortly to give way to a profound change in both attitude and style.

1592-1600

Boy Bitten by a Lizard

Dating from 1595, this was among the first of the artist's works "painted for sale" while with Monsignor Pandolfo Pucci. It has been interpreted as an allegory of the senses, the seasons, or the temperaments.

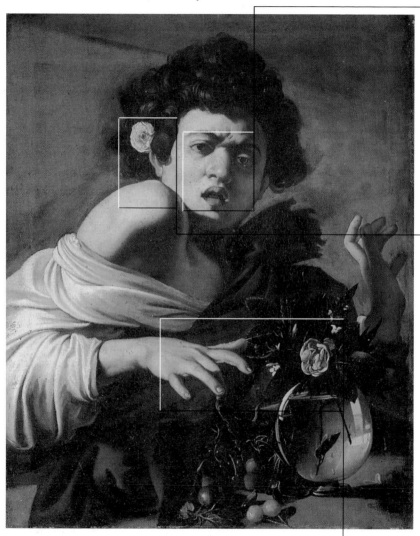

■ In the face of the youth, Caravaggio leaves visible the movements and superimpositions of the brush. He achieves a masterly blend and variety of tones, which emphasize the extremely beautiful detail of the frown that furrows the boy's forehead.

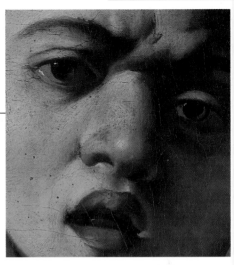

■ The movement of the exposed shoulder and the flower tucked in the hair somehow seem to convey the everyday surroundings to which Caravaggio was accustomed. His frequent portrayal of effeminate youths suggests that he spent time with young male prostitutes.

■ In this pencil and charcoal drawing by Sofonisba Anguissola (Musei e Gallerie di Capodimonte, Naples), the painter, a pupil of Bernardino Campi, clearly demonstrates her debt to previous Lombard iconography.

■ The movement of the hand, abruptly withdrawn from the bite of the lizard, is depicted with a realistic sense of immediacy. The painting has been interpreted symbolically in various ways: an allegory of love's wounds; a moral lesson on pleasure, soon transformed to pain; or a warning about the ephemeral nature of youth and how death may occur at any time.

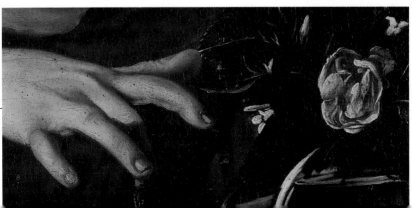

Naturalism

"**T**o paint in the manner, and with the example to hand, of the natural is the most perfect of all systems…this is how Caravaggio…and others painted." Thus wrote Vincenzo Giustiniani, Caravaggio's admirer and client, in 1625. A hint of the renewed interest in naturalism came from the academy of the Carracci in Bologna between 1585 and 1588. It marked the final stage of Mannerism. In an environment receptive to all matters of art, science, and literature, its aim was to renovate painting in the spirit of northern Lombard naturalism, in opposition to artificiality and Neoclassical Italian tradition. The artist must proceed from what is true in order to highlight the design and color of the 16th-century masters, and shun conventionality, because nature as a component of art is the best way of affecting human attitudes and feelings. Moreover, this was a revival of the Flemish genre of still life with figures, known in Italy through the Campis. Caravaggio, in his first Roman works, was to achieve a synthesis of the Lombard and the Roman experiences, but, unlike the Carracci, he preferred a direct and immediate method of painting.

■ Girolamo Sciolante, *Corner Frieze*, 1549–50, Palazzo Comunale di Monterotondo. In the last days of Roman Mannerism, artists found it difficult to abandon the artificial forms of putti in favor of more realistic painting.

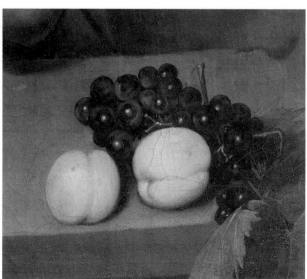

■ In this detail from Caravaggio's *Sick Little Bacchus* (Galleria Borghese, Rome), a fine example of naturalism is evident in the randomly arranged fruits.

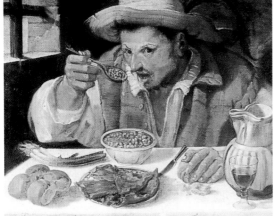

■ This work has been thought by some to represent the allegory of *vanitas* (beside the mirror is a skull). However, the engraving is actually a mirrored self-portrait, probably derived from a lost work by Caravaggio. Mirrors were often employed by artists of the time to help create a measure of naturalism.

■ Annibale Carracci, *Bean Eater*, c.1584, Galleria Colonna, Rome. This famous image of exceptional immediacy is taken directly from life.

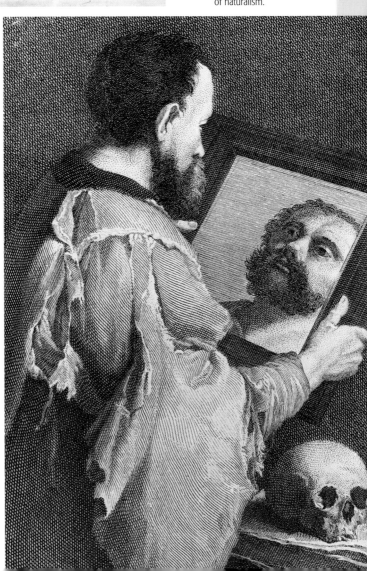

■ Paolo Porpora, *Flowers with Crystal Bowl*, c.1650, Musei e Gallerie di Capodimonte, Naples. This work is a fine pre-Baroque still life.

Large-scale works in Rome

■ Santa Maria di Loreto al foro Traiano, Rome. The imposing octagon by Jacopo del Duca reflects the full authority of Mannerism.

The death of Sixtus V brought no interruption to the wave of artistic fervor that the pope had initiated. Rome, more than ever, emerged as the focus of attraction for artists and was to enjoy this cultural pre-eminence throughout the 17th century. In the final decade of the 16th century, one of the most important artistic events was undoubtedly the immense decorative cycle for the nave of Santa Maria Maggiore, commissioned by Cardinal Domenico Pinelli and completed in 1593 by artists already active in the Sistine project. Causing a sensation with the unveiling of a cycle in one of the city's great palaces, Annibale Carracci was a decisive new presence, summoned to Rome by Odoardo Farnese. From 1595, With his decoration of the first study and then the gallery, he laid the foundations of the pictorial revival, which reverted to the themes and language of classicism. Equally important for the later development of painting in Rome were the three Titian canvases for the study of Alfonso d'Este. The architect Domenico Fontana, however, left the city for good when relieved of his official duties by Clement VIII who replaced him with Della Porta.

■ Between 1597 and 1604, the Palazzo Farnese became a rich site for painting, thanks to the gallery frescos of Annibale Carracci.

■ On the instructions of Paul V, the block surrounding the dome of St Peter's basilica was transformed into a longitudinal structure.

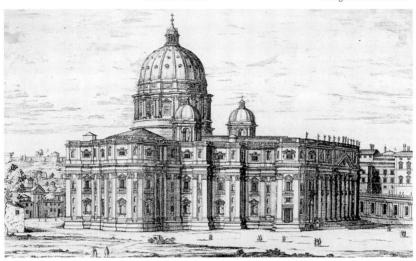

■ The paintings done by Titian for the study of Alfonso d'Este ended up in the city of the popes. They comprised the *Offering to Venus*, the *Bacchanalia,* and *Bacchus and Ariadne*, which were to have a decisive influence upon painting in the first half of the 17th century.

■ Giovan Battista Falda, *Chiesa di Santa Susanna*, engraving, 1665–90. This church was the first example of Baroque in Rome. Prior to embarking on his major activities at St Peter's, Carlo Maderno brought a vigorous, free style to his work on Santa Susanna. The facade was completed in 1603.

Clients, collectors, and scholars

The young Caravaggio was introduced to a particularly select milieu of culture and life. Initially, his work was intended for a restricted circle of intellectuals – his contact with philosophers ranged from Giordano Bruno to the Neo-Platonist Francesco Patrizi, lecturer at Rome University. Theirs was an interest shared by Cardinal Borromeo, exponent of the Oratorian revival and an admirer northern naturalist painting. However, the Neo-Platonists had to take account of the directives of the Council of Trent and the group soon dissolved, having exerted only a marginal influence on Caravaggio. During these years, he produced paintings for sale with Arpino and made contact with the mad academicians of Perugia. The latter were exponents of a school of poetry full of word play, metaphor, and elaborate conceits, typified by the work of Giambattista Marino, which sought to combine reality and morality. It was in this environment that political orientations in Rome were also defined: on one side were the francophiles, more receptive to modern culture; on the other the hispanophiles, more obedient to the principles of the Counter-Reformation.

■ Maffeo Barberini, portrayed in an engraving by Gaspar Grispolit, 17th century, Raccolta Bertarelli, Milan. The future Pope Urban VIII (1623–44) is depicted within an oval surrounded by allegorical images of the Muses, an indication of his declared love for music and letters.

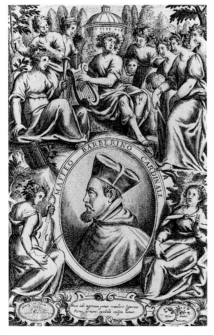

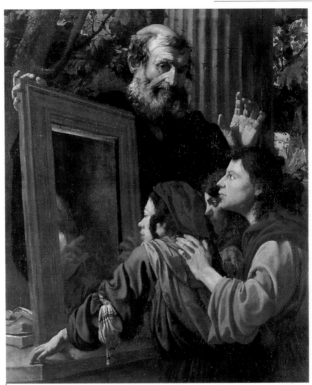

■ In the poetry of Aurelio Orsi (*Carmina*, 16), brother of the painter Prosperino delle Grottesche, there are signs of the sensibility expressed by Caravaggio in some of his earliest works, such as *Mary Magdalen* and the *Boy Bitten by a Lizard*.

■ *Galileo Galilei*, etching by Bettini, 18th century. Scientist, philosopher, and scholar, Galileo was greatly appreciated by Roman collectors, for whom he represented a reference point of modern knowledge. His reflections on the study of natural reality and its manifestations, to which the human mind must adapt, contributed to the evolution of the 17th-century scientific attitude to art.

The return to easel painting

In late 16th-century Rome, where painting principally assumed the form of great frescos based on historical subjects (both secular and religious), the technique of easel painting also found popularity, notably among writers and art lovers. This method was perfectly in accordance with the new tastes of collectors in that it could be practised both in the studio and the university in a confined space that encouraged cultural discussion. Furthermore, the easel painting was easily transportable and could either be sold or donated. The practice helped to define various genres of painting, in which artists would soon come to specialize.

■ Piefrancesco Mola, *Two Connoisseurs Admiring a Painting*, pen and ink, Pierpont Morgan Library, New York.

Prostitutes and rent-boys, gypsies and musicians

The subject matter of certain works of the 1590s concentrated on aspects of society that had hitherto been little explored. Caravaggio painted from life, turning out pictures that contained people and places clearly observed at first-hand. Bellori states that "having arrived in Rome he lived there without any address or plans", before being taken in by Cavalier d'Arpino. However, it is likely that the artist would have consorted with the very people that he would soon be painting. Working with ordinary folk in modest surroundings would have come naturally to him, and as he grew accustomed to producing small studio pictures and copies for patrons, he never neglecting the images of everyday events and real life that would soon be reproduced in his first genre works. The subjects depicted in these scenes are far removed from both classical figures and the fashionable models of the day. Prostitutes, gypsies, and other street characters, they are, however, wholly genuine, as if bearing traces of the pain, fatigue, and exertion of everyday life – toil of a kind that the painter evidently knew well.

■ Hans Ulrich Franck, *Hostelry*, c.1648, engraving. Such places inspired much naturalistic painting.

■ One of the first followers of Caravaggio was Valentin de Boulogne, who painted genre subjects that included gamblers, musicians, and gypsies. By virtue of its theme, *The Cardsharp*, c.1623 (Gemäldegalerie, Dresden) was for a long time considered a work by Caravaggio himself.

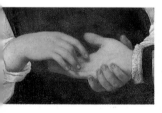

■ A familiar sight in Rome was the gypsy reading the hand for good luck (Musei Capitolini, Rome).

■ *Mary Magdalen*, 1594–96, Galleria Borghese, Rome: yet another face drawn from the working classes.

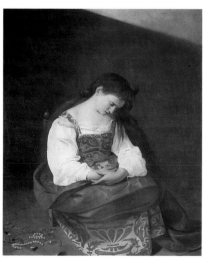

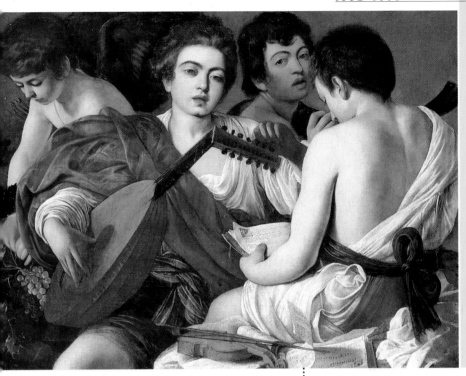

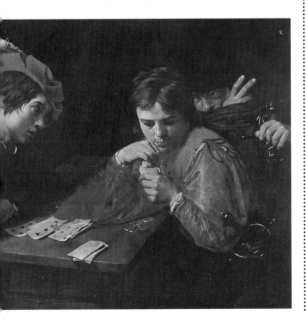

The presumed homosexuality of Caravaggio

Considering the frequency with which effeminate and provocative male figures appear in Caravaggio's works, many critics have interpreted in them evidence of the painter's own homosexuality and sordity of lifestyle. One such revealing picture is the *Concert of Youths* (Metropolitan Museum of Art, New York). This has fed the imagination of those who see the artist in the first flush of romantic discovery, reinforcing the image of the "doomed painter". This interpretation, however, may derive from the inability to read the artist's works according to the pictorial rules of the time. Thus most critics prefer to regard his activities as those of an impulsive genius.

Boy with a Basket of Fruit

Now in the Borghese Gallery in Rome, this work dates from about 1593–94 and belonged to the Cavaliere d'Arpino. The subject treats both youth and nature but has been interpreted as an allegory of Taste.

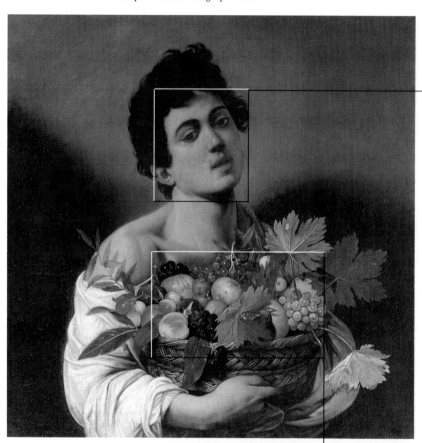

■ This still life, with its combination of juicy fruits and withered leaves, sumptuousness and decomposition, was the type of subject calculated to encourage Caravaggio to seek all manner of subtle and hidden meanings.

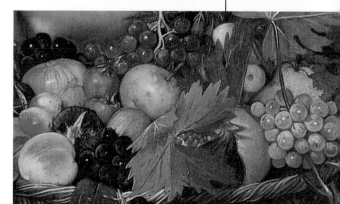

■ The face of the young man is reminiscent of that of the model used for other works of this period, particularly the central figure in the *Concert of Youths* (Metropolitan Museum of Art, New York) and the *Boy Bitten by a Lizard*. It has also been suggested that this is one of the so-called mirror portraits that Caravaggio made during this early phase or that it may be an actual self-portrait.

■ A very different treatment of self-portrait is evident in *Sick Little Bacchus* (detail, c.1591, Galleria Borghese, Rome). The pale flesh of the subject's face, rendered in green or bluish tones, suggests some kind of illness; alternatively, it may be intended to depict a particular state of mind, such as the so-called "moon" or "poetic" madness, thanks to which artists suffering from a melancholy temperament were supposed to have been capable of doing their best work.

■ This still life detail from *Bacchus* (Galleria degli Uffizi, Florence) was done shortly before the *Boy with a Basket of Fruit*, making the famous basket of the later work virtually an exercise in style. The bunch of grapes that juts from the basket and lies flat on the table creates a new relationship between the space and the figure, creating an extraordinary glimpse of reality.

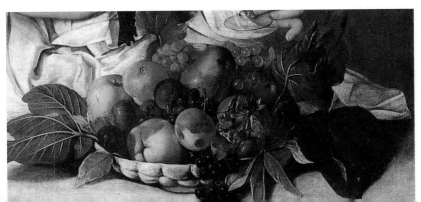

Origins of the still life

The supremacy of the humanist position, apparent in 16th-century Italy, led to the widespread use of natural elements in both sacred and secular painting. This impulse was even more pronounced and deliberate among painters who, whether for aesthetic reasons, out of commercial interest, or through political contacts, had links with Flanders, where artists were experienced in portraying natural detail. Although in his entire career he painted only one autonomous still life, Caravaggio set about incorporating still life elements into his paintings and they became a fundamental feature of his work. By this time, the genre was already considered by academicians to be "inferior natura" and almost exclusively the province of the Flemish and the fresco decorators, such as Giovanni da Udine. Caravaggio began to apply himself to this genre when he was with Arpino, who wanted an apprentice who could compete with the works of Flemish origin by representing reality in an analytical manner, accurately conveying a sense of three-dimensionality.

■ Giovanni da Udine, *Festoons,* c.1519, Villa Farnesina, Rome. The activities of the decorative painters known as "grotesques" represented one of the art trends of late 16th-century Rome. This attracted Caravaggio because of its attentive approach to naturalism.

■ Caravaggio, *Bacchus*, detail, c.1598, Galleria degli Uffizi, Florence. This splendid isolated element of still life is depicted within a figure painting and becomes an important part of the whole work. The concept brings Caravaggio close to his Lombard origins, his love of detail being typical of northern painting. In this painting, the still-life element is no mere secondary factor, but a key to our reading of the entire work.

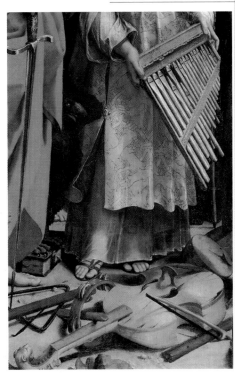

■ Raphael, *Santa Cecilia*, detail, c.1513, Pinacoteca Nazionale, Bologna. Here, elements of still life, albeit conceived with a subordinate function, convey the artist's vision, which is to some extent abstract rather than naturally figurative. This is evident in the scattering of musical instruments, teated like a series of pictures within a picture.

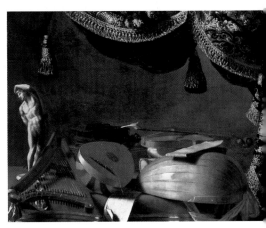

■ Colantonio, *St Jerome in the Study*, 1445–50, detail, Musei e Gallerie di Capodimonte, Naples. Here, the painter separates from the rest of the composition the iconographic attributes of the saint. These are depicted in a style that is wholly northern in its detail.

■ Baschenis, *Still Life with Musical Instruments,* c.1650, Accademia Carrara, Bergamo. Still life as a separate genre was by this time established. Baschenis often depicted musical instruments, which enabled him to bring out striking optical effects and perspective.

Cardinal Federico Borromeo

Son of Count Borromeo (uncle to St Charles) and Margherita Trivulzio, Federico initially showed a special liking for military affairs. Soon, however, this youthful passion became secondary to his interest in studies, which accompanied the pursuit of his vocation for the priesthood; he was already wearing clerical habit when he attended Pavia University. In 1586, aged 22, he was in Rome, embarking on an ecclesiastical career as manservant to Sixtus V. Here, he received an ascetic upbringing at the school of St Philip Neri and continued his studies in various disciplines. The following year, Federico was appointed cardinal, but only entered his Milan diocese in 1595, the delay owing to his reluctance to accept high pastoral office; never one to seek honors, he felt he had a more serious calling. He was increasingly attracted by study and keenly aware of his communal responsibilities. Having settled in Milan, he promoted the initiatives of his cousin Charles, who, as archbishop of Milan from 1560 to his death in 1584, had been similarly interested in the need for religious, educational, and social reform. A patron of arts and culture, it was Federico who conceived the idea of the Ambrosian Library, opened to the public in 1609, the Doctors' College, and the Academy of Painting and Sculpture.

■ *Federico Borromeo* (1564–1631), engraving. Federico was the second successor to St Charles in the diocese of Milan and, like him, was a reformer of the Ambrosian church. Feeling himself better suited to a quiet life of study, after being appointed cardinal of Milan, he did not enter his diocese for a further eight years. Even so, he soon became, like his cousin and predecessor, a passionate reformer.

■ Leonardo da Vinci, *Portrait of a Musician*, c.1480, Pinacoteca Ambrosiana, Milan. Among the works by great artists brought together for the opening of the library, founded in 1609, four years before the institution of an annex for the Academy of Painting, Sculpture and Architecture, there were three works by Leonardo. Only the *Musician* is now believed to have been done by him.

■ Among the many writings by Borromeo on music, moral philosophy, biblical exegesis, hagiography, liturgy, politics, and geography was a text on sacred painting, dedicated to his beloved Ambrosian Library.

FEDERICI
CARD. BORROMÆI
ARCHIEPISC. MEDIOLANI
DE
PICTURA SACRA

Sacred art literature after the Council of Trent

After the ruling on sacred images by the Council of Trent, during the first Provincial Council (1565), Cardinal Charles Borromeo (St Charles) forbade the painting of popular subjects without official approval from the church or the precedent of authoritative writers. He also recommended the bishops to instruct artists on proper procedure. In 1570, Molano published a treatise, *De picturis et imaginibus sacris*, which maintained the need to base each and every figuration on the scriptures and sacred stories that were solidly verified. After 1582, however, the Bolognese Cardinal Paleotti, without imposing special rules or prohibitions, proclaimed the need for art to be respected and loved for its own sake.

Basket of Fruit

This is the only independent still life attributed to
Caravaggio. Dating from about 1597 and now in the
Pinacoteca Ambrosiana, Milan, it is uncertain whether
it was bought by Cardinal Borromeo or whether it was
donated to the library by Cardinal del Monte.

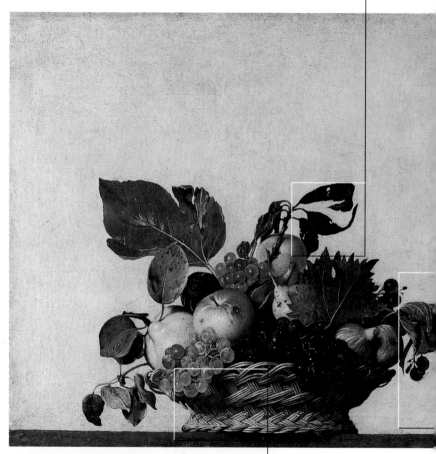

■ An extraordinary
sense of naturalism
emerges from the
balanced position of the
basket, which stands out
as a highly innovative
example of dynamic
experimentation.

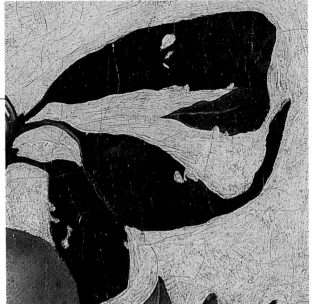

■ The background seems to intrude upon the contours of the three frail, curling leaves. The clear spaces between the leaves is an artistic expedient to highlight the moth-eaten effect and to convey an almost tactile sensation of the crumbled margins. At the same time, a suggestion of back-lighting accentuates the sense of depth against the bright ground.

■ The withered leaves strongly suggest that the subject symbolizes the corruptibility of nature. For some, the painting alludes to the Church: the same basket contains the illuminated faithful and the sinners.

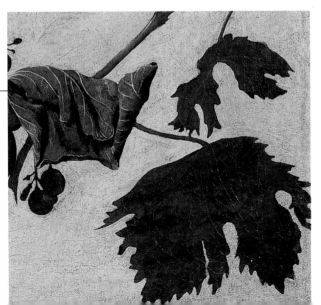

49

Successes, replicas, copies, and variants

Caravaggio's method of painting from life with actual models ruled out, for some time, the possibility of several autograph versions of a single subject. However, cases did later arise of two versions of the same subject (*Boy Bitten by a Lizard*, *Fortune Teller*, and *Lute Player*). Based on the testimony of Caravaggio's biographer Mancini, who believed the *Boy Bitten by a Lizard* to have been painted for sale, the theory of the autograph copy came to be considered in a new light. Possibly for promotional reasons, the painter evidently replicated works at the behest of a client. The second work, however, was never an identical copy: although subject and composition did not change, there were variations in the background detail or in the still life. Caravaggio always worked without preparatory sketches, but with rapid, darting strokes that would have been alien to a copyist. As the years passed, he began to redo a subject by interpreting it in a different manner. The various versions demonstrated diversities of composition, variations of color, and alterations in the quality of light illuminating the figures.

■ Among Caravaggio's most often repeated subjects is *St John the Baptist*. This version (Nelson Gallery-Atkins Museum, Kansas City) can be dated from the end of the 1590s for its full-length figure, the unusually turned shoulder, and the rather harsh bands of light that strike the subject.

■ The two versions of *Boy Bitten by a Lizard* (left, National Gallery, London; right, Fondazione Longhi, Florence) differ subtly, principally in the use of light.

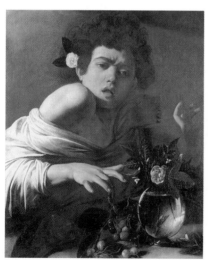
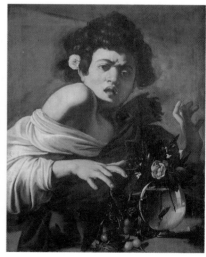

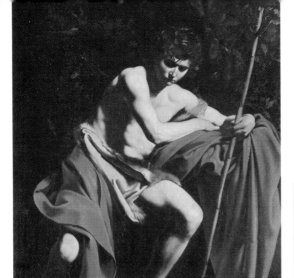

■ The Spanish *St John the Baptist* (Toledo Cathedral) is not unanimously attributed to Caravaggio for reasons of style: despite an integral plan, it lacks Caravaggio's usual vigor, the treatment here being extremely delicate.

■ *St John the Baptist,* c.1598, Musei Capitolini, Rome. Caravaggio here shows his early artistic maturity by portraying an attitude along the lines of Michelangelo (the *Nudes*), perhaps in an attempt to bring naturalism to the Sistine model.

Annibale Carracci
and the Farnese Gallery

■ *Annibale Carracci,* in an engraving for Carlo Cesare Malvasia's *Life of the Bolognese Painters* (1678).

■ Annibale Carracci, *Triumph of Bacchus and Ariadne.* This crowded painting, which covers the central part of the barrel vault of the Farnese Gallery, Rome, is a work of prodigious richness and invention.

Annibale Carracci, founder of the Accademia di Pittura degli Incamminati, had by 1595 stretched his expressive talents to the limits, and Bologna appeared to have little more to offer him. He left his city and travelled to Rome, summoned by Cardinal Odoardo Farnese, who commissioned him to carry out the fresco decoration of his private study. The Roman environment gave Annibale the opportunity to transform his art: the transition from tentative poetic effects to celebratory idealism combined happily with naturalism and elaboration of classical models, thanks to his familiarity with Raphael and Michelangelo. Within two years, the room was finished and Carracci entered upon his greatest Roman commission, the decoration of the gallery of the Farnese Palace. Initially, the pictorial cycle followed the conception of the work carried out by the cardinal's father, Alessandro Farnese, who died in Flanders in 1592. However, in due course, the decorative style was modified in a series of fables from Greek mythology, which incorporated the Neo-Platonist concept of the heavenly Venus and the terrestrial Venus. Abandoning the ordinances of the Council of Trent as they applied to the art of Bologna, Carracci gave his imagination free rein, rediscovering the classical world and basing his evocations of antiquity on the great masters of the Renaissance.

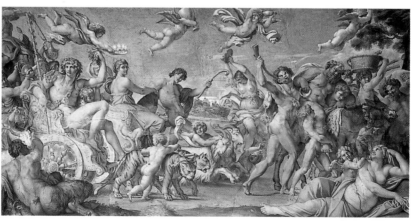

■ The Farnese Palace,
built by Antonio da
Sangallo the Younger
for Cardinal Alessandro
Farnese and completed
by Michelangelo (1546),
is one of the most
important monuments
of 16th-century Roman
architecture, which
mingles the purest
classical motifs and
forms with a 15th-
century sense of
measure and balance.

■ Carracci's original
composition envisaged
a series of nine
paintings contained
within gilded cornices.
Mercury, messenger
of the gods, descends
to earth and hands
to Paris the golden
apple of discord.

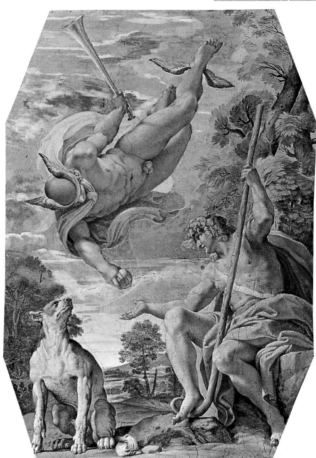

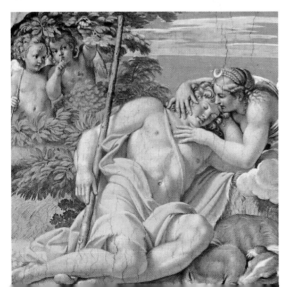

■ Annibale Carracci,
Diana and Endymion.
In his return to the
classical vein, Carracci
was strongly influenced
by Raphael, from whom
he borrowed the style
of *Venus and Adonis*,
which was painted
for Cardinal Bibbiena
and reproduced
by his engravers
Marcantonio Raimondi
and Agostino Veneziano.

1592-1600

The first great
religious subjects

Towards the end of the century, Caravaggio began to paint religious subjects with extraordinary innovation: he treated them as genre pictures set in natural surroundings, so as to evoke the link between the human and the divine. Emerging from his early phase, he was now free of the rules he had learned as a boy and began to experiment in the use of light in a new way, creating contrasts that seemed to permeate the whole painting. His earliest religious works were still designed for private collectors, for whom he deliberately distanced himself from official iconography; this was not in order to defy church doctrine but reflected the artist's quest for a more faithful adherence to the Bible and the imagery of primitive Christian painting. Caravaggio was much closer than at first appears to the current end-of-century trend of iconography, not so much motivated by official taste as by his own personal attitude towards the faith. His earliest paintings thus involved themes such as ecstasy, profound meditation, major conversions, and biblical episodes that testified to the presence of the Divine in human history.

■ Caravaggio, *Sacrifice of Isaac*, c.1595, Confederación de Cajas de Ahorro, Madrid. The angel turns to Abraham with humanity as he strokes the ram to be sacrificed in place of Isaac.

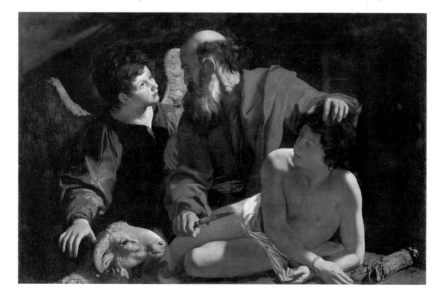

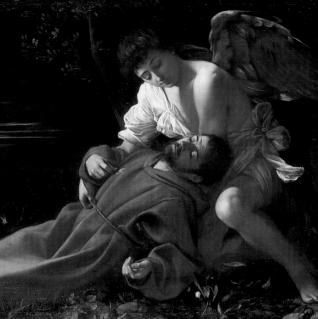

■ Caravaggio, *The Ecstasy of St Francis*, Wadsworth Atheneum. Hartford, Connecticut. This is perhaps the first work of a religious character that can be attributed to Caravaggio during the early 1590s. The theme postdates the Council of Trent: the stigmatization of St Francis reflects the motif of the *Imitatio Christi*.

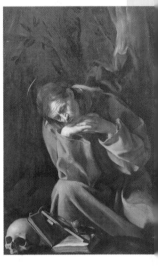

Caravaggio's religion

The image of Caravaggio as an unbeliever can today be dismissed. From the surroundings in which he was raised (a small, middle-class family, with an uncle and a brother who were priests) and from his experiences in Milan and Rome, he developed a religious feeling that bound him to the church of his origins – notable for its poverty and pure ideals. The company of Cardinal Borromeo and the Oratorians drew him naturally to the innovative branch of the Counter-Reformation that looked forward to the return of the Church to the values of purity, sobriety, and humility, in contrast to Renaissance luxury.

■ Caravaggio, *St Francis Penitent*, Pinacoteca Civica, Cremona. Usually dated from the summer of 1606 for its brown colors and the spirituality of the subject, this work is noteworthy for the prominent detail of the skull and the book held open by the cross.

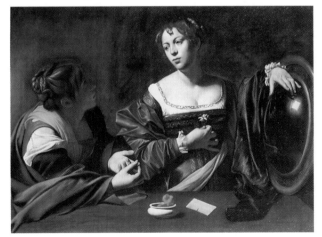

■ Caravaggio, *Martha and Mary Magdalen*, c.1597, Institute of Arts, Detroit.

Judith Beheading Holofernes

This painting, first discovered in 1951 at an exhibition in Milan and now housed in the Galleria Nazionale di Arte Antica, Rome, is probably not the only *Judith* by Caravaggio. It dates from the end of the 16th century.

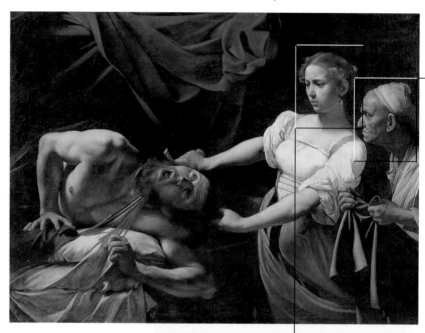

■ The terrible subject of Judith mercilessly cutting off the head of Holofernes is handled by the painter with great restraint. The grim determination evident in the features of the young woman is mitigated by a frown, a sign perhaps of the human sadness that either ignores or does not comprehend the divine significance of the event.

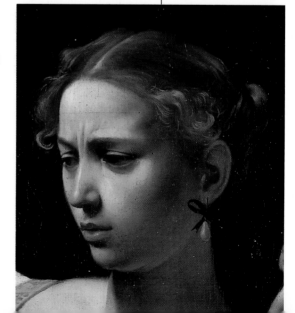

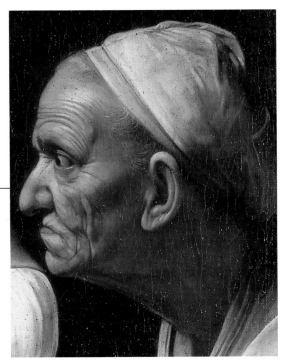

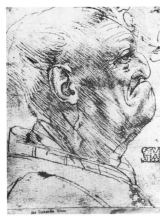

■ Caravaggio's image of the servant may hark back to the Lombard taste for caricature and to some of the heads drawn by Leonardo. This study, with its protruding ears and frown, is strikingly in the style of Leonardo.

■ The old serving woman with her intent stare, ready to receive the victim's head, forms an indispensable part of the biblical story. The grimly attentive expression greatly accentuates the dramatic quality of the scene.

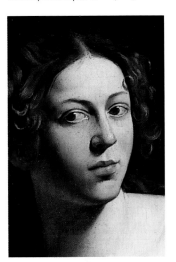

■ Judith's face appears frequently in Caravaggio's works: in fact, the model, Fillide Melandroni, posed for him on several other occasions: for *St Catherine* (left, detail, Thyssen Collection, Madrid); for *Phyllis* (formerly Kaiser Friedrich-Museum, Berlin); and for the figure of Martha in *Martha and Mary Magdalen* (Institute of Arts, Detroit).

■ Leonardo da Vinci, *Studies of Caricatures*, Biblioteca Ambrosiana, Milan. This drawing studies the puckered mouth of a toothless man.

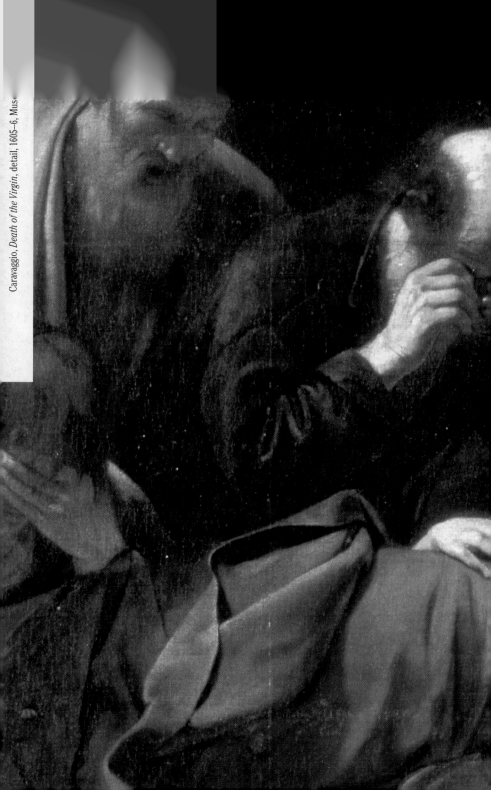

Caravaggio, *Death of the Virgin*, detail, 1605–6. Mus

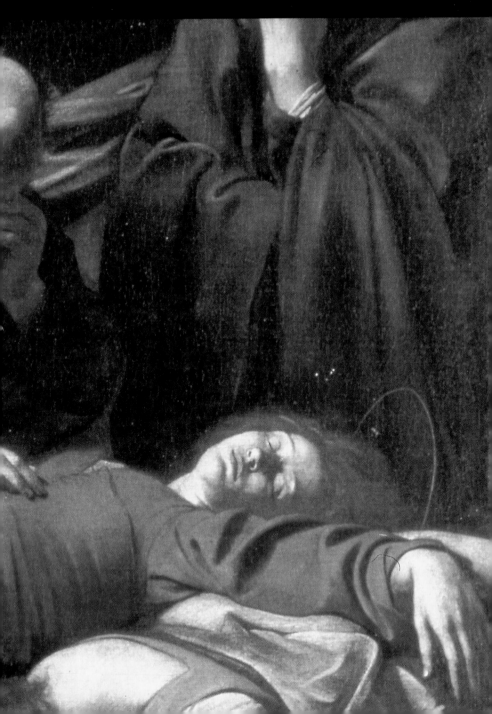

The masterpieces
of a criminal

1600-1606

The San Luigi dei Francesi commission

everal fortunate coincidences brought Caravaggio his first important public commission, probably through the intervention of Cardinal del Monte, a member of the cathedral workshop of St Peter's. The administrators of San Luigi had repeatedly petitioned the pope and the workshop to complete the decoration of their church. Having tried in vain to renew the assignment with the Cavalier d'Arpino, who had already done frescos for the vault, they decided in 1598 to seek a new painter. On July 23, 1599, Caravaggio was appointed and given a contract that provided a fee of 400 scudi. The following May, the chapel, with stripped walls, was opened to public worship. It was clear that no more frescos were envisaged (the scaffolding, in fact, would have prevented it) and this pointed the way towards paintings on canvas, virtually an innovation in Roman chapels of the period. The two paintings required of the artist (dedicated to the calling and martyrdom of St Matthew) were delivered two months later than the deadline of the agreement, according to which they were to be exhibited within a year. However, this did not prevent them becoming a huge success, leading, a year and a half later, to the prestigious commission of an altarpiece to replace the statue by Cobaert, which remained incomplete.

■ The church of San Luigi dei Francesi in an engraving by Giovanni Battista Falda (from *Il nuovo teatro e le fabriche ed edifici di Roma moderna*, 1665–90)

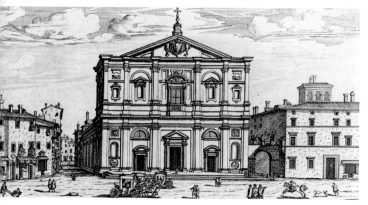

■ Caravaggio, *St Matthew and the Angel*, 1602, Contarelli Chapel, San Luigi dei Francesi, Rome. The gesture of the angel who is teaching St Matthew is typiical of that of a master instructing a pupil in medieval rhetoric. This is Caravaggio's second treatment of the subject but, in this case, there would be no objection: the altarpiece satisfied the demands of both the Church and the commissioners.

■ The statue of *St Matthew and the Angel* was begun, before 1593, by Jacob Cobaert for the altar of the Contarelli Chapel and completed, in the figure of the angel, by Pompeo Ferrucci. Cobaert's assignment was then cancelled in favor of a canvas by Caravaggio.

■ Caravaggio, *St Matthew and the Angel*, 1602, formerly at the Kaiser Friedrich-Museum, Berlin. This, the artist's first version, was refused because of the allegedly vulgar pose. Bought by the marquis Giustiniani in 1815, it was donated by his heirs to the Berlin museum, where it was destroyed in World War II.

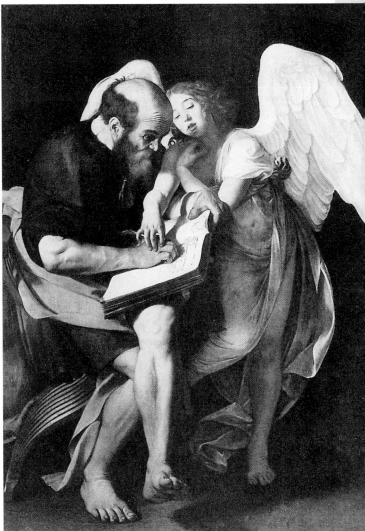

The Contarelli Chapel, a controversial story

BACKGROUND

\mathbf{T}he episodes leading to Caravaggio's work for the Contarelli Chapel were characterized by controversy. In, 1565, Mathieu Cointrel (Matteo Contarelli) acquired a chapel in San Luigi dei Francesi, the French church in Rome, and planned decorations inspired by the life of St Matthew. The work was entrusted to the Lombard painter Girolamo Muziano, who never started work on it. On the death of Cardinal Contarelli, twenty years later, the church received the greater part of his legacy in order to complete the work and Virgilio Crescenzi, executor of the will, officially commissioned the sculptor Cobaert to finish the altarpiece. Soon afterwards, the decoration of the walls was entrusted to the Cavaliere d'Arpino, who in early June of 1593 completed the vault with the scene of *St Matthew Reviving the Daughter of the King of Ethiopia*. However, Arpino was engaged elsewhere and Crescendi simply delayed the work, meanwhile content to enjoy the interest on the legacy. The commission lasted until 1598, when the church administrators finally took Crescenzi to court, compelling him to terminate matters.

■ Matteo Contarelli, datary of Pope Gregory XIII and cardinal from 1582, in an engraving of the 14th century.

■ Girolamo Muziano, *Raising of Lazarus,* c.1555, Musei Vaticani, Rome. This painting brought Muziano such success that he was asked to work in Orvieto Cathedral. Here, he shows a tendency towards the Venetian style, with attention to naturalistic detail and to the religious theme.

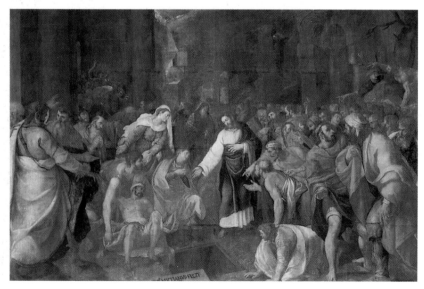

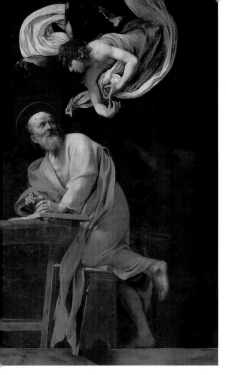

Martyrdom or execution?

Radiographic investigations have revealed that Caravaggio's *Martyrdom of St Matthew* for the Contarelli Chapel was a third version transformed from the first two: a symbolic Renaissance-style representation has been converted into a Baroque scene of drama. The retouchings show that the work was carried out in stages until it produced a final image without any of the original ideas. The scene is brutal, depicting an assassination, not a martyrdom: it lacks the sense of hope and sublimity that sprang from the execution of Giordano Bruno. The assassin is an avenger eliminating a rebel, the saint receives the martyr's palm but keeps it at a distance, the onlookers disperse, leaving him alone, and the sacred event becomes an encounter of opposed interests.

■ Caravaggio, *St Matthew and the Angel,* 1600, San Luigi dei Francesi, Rome. This second, approved painting of *St Matthew and the Angel* shows the Evangelist inspired by the angel sent by God. It was exhibited in 1602 in the Contarelli Chapel.

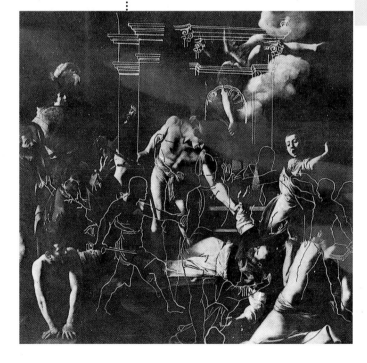

Martyrdom of St Matthew

The vivid and dramatic scene of the *Martyrdom of St Matthew* was completed and exhibited in the Contarelli Chapel of San Luigi dei Francesi in 1600. Widely celebrated, it was Caravaggio's first great public success.

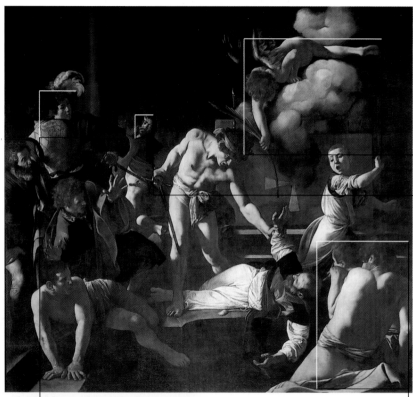

■ The young man with the oval feathered cap and the "Giorgionesque" air may have been the painter's friend, Mario Minniti. The enigmatic function, the pensiveness, and the feeling of poetic realism conjure up the prevailing atmosphere of the Del Monte household.

■ In the memorandum that Contarelli left for the decoration of his chapel, he does not specify the presence of the angel on the cloud, who handles the martyr the palm, symbol of his sacrifice. His presence represents, in fact, an extraordinary element, an exceptional note in Caravaggesque procedure: the traditional iconography of clouds supporting the angel appears distorted, so that the cloud seems to have quite the opposite effect – that of expelling him.

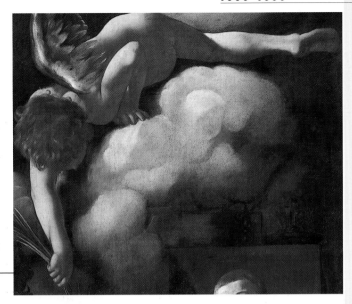

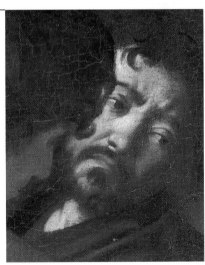

■ In the foreground, the naked youth with hunched shoulders who recoils from the scene is a clear reference to Mannerist tradition, used in particular by the Zuccaris. He resembles one of those "figures for hire", in the words of Annibale Carracci, employed to fill in the empty spaces of the composition.

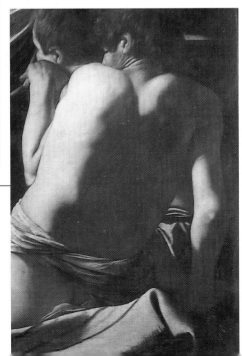

■ The most astonishing feature of the composition is the introduction of the self-portrait. Caravaggio, depicting himself for the third time after the *Sick Little Bacchus* and the *Concert of Youths,* is portrayed with a short beard and a sad, careworn expression, as if an unwilling, perturbed spectator in the shattering scene of the martyr's death.

Calling of St Matthew

This was the second great canvas painted for the Contarelli Chapel in the church of San Luigi dei Francesi. The subject – the calling of the tax-collector Matthew to follow Jesus – was often imitated by Caravaggio's followers.

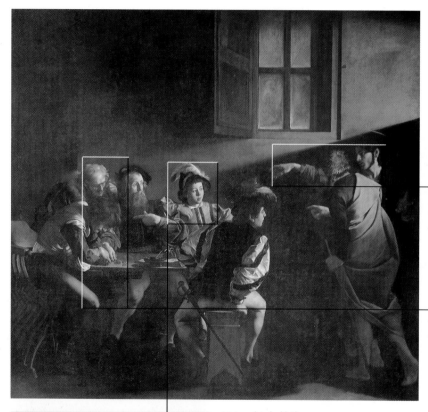

■ Associated with the painter's youthful period is his friend and model Minniti, here given a "Giorgionesque" costume and bearing. This is in keeping with the Venetian tradition of giving color a primary role in the reproduction of naturalistic detail.

■ The gesture that Caravaggio may have had in mind for his figure of Jesus derives from a celebrated Renaissance archetype: the gesture of God summoning Adam to life in Michelangelo's *Creation* frescos in the Sistine Chapel.

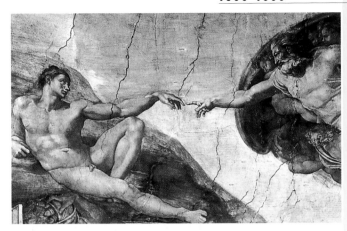

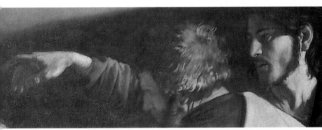

■ Jesus calls upon Matthew with an eloquent gesture: the arm that stretches out behind the head of Peter (only added in the second version) conveys the notion that this individual has been selected from afar.

■ The tax-collectors counting the money are portrayed in such a realistic manner that the characters have sometimes been identified as gamblers. This partly arises from Sandrart's mistaken interpretation whereby Matthew was surprised by Jesus while gaming and drinking in a tavern.

■ Masaccio, *Stories of St Peter*, detail, 1425–27, Cappella Brancacci, Santa Maria del Carmine, Florence. This fresco shows a further example of Renaissance-style gesture, which Caravaggio evidently knew well and which he was able to reproduce.

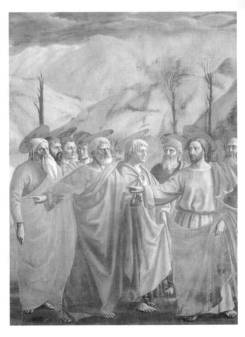

Altar painting at the beginning of the 17th century

During the course of the 16th century, the typical altar painting took the form of a monumental, curved wooden panel, the sacred personages being arranged within a uniform space, according to a hierarchy linked with the scene of the Sacred Conversation, showing the Virgin and Child enthroned, surrounded by saints and, in some cases, the donor. Altarpieces of this type were found all over the Veneto and in Emilia Romagna, and it was due to the contribution of these two regions that a change came about at the end of the century. When Ludovico Carracci painted his *Bargellini Altarpiece*, it still had echoes of Titian's innovative *Pesaro Altarpiece*, for it moved the Virgin, which traditionally occupied a central position, slightly to the right. If the new arrangement initially affected the composition, it soon impinged on the subject itself: Sacred Conversations gradually vanished, giving way to edifying narratives expressly determined by the Counter-Reformation, including episodes of the martyrs, miraculous deeds, saintly ecstasies, and scenes derived from the biblical and hagiographic sources, often with sentimentalized characters.

■ With his *Bargellini Altarpiece,* painted in 1588 with Titian in mind, Ludovico Carracci introduced a new type of composition: the Virgin and Child are no longer in the centre but have been moved to the right, serving as intermediaries between the kneeling saints and heaven, which is symbolized by small flying angels.

■ Giovanni Battista Paggi, *Stoning of St Stephen*, 1604, Chiesa del Gesù, Genoa. This is one of the artist's most successful works, completed after twenty years of exile in Tuscany. It was a period when a new generation of local artists was establishing itself in Genoa.

■ Carlo Francesco Nuvolone, *Miracle of the Cripple*, c.1659, Basilica di San Vittore, Milan. While retaining compositional elements of the preceding century, such as the background architecture and the Mannerist figure of the healed cripple, the subject represents one of the most popular among artists at the beginning of the 17th century: a miraculous event depicted in calm, colloquial terms.

■ Guido Reni's treatment of the biblical narrative in his *Massacre of the Innocents* (1611, Pinacoteca Nazionale, Bologna) is a disconcerting combination of dramatic realism and formal purity.

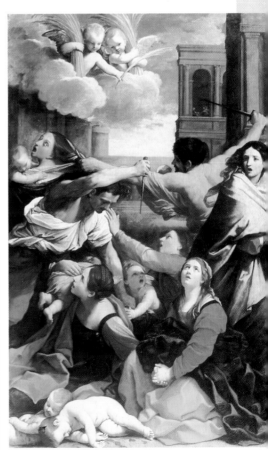

Lawsuits, successes, and refusals

The exhibition of his paintings for San Luigi dei Francesi brought Caravaggio immediate fame, a number of new clients, and some important commissions. He had convincingly changed the former conception of chapel decoration: the traditional use of frescos could be replaced by large canvases, the personages could be represented as living characters, and the religious significance of the tragedy heightened by astute use of light. The success of the Contarelli enterprise led directly to the prestigious commission from Monsignor Cerasi, who was nevertheless the cause of disputes, misunderstandings, and bitter criticism. It was by now evident that life was not all that simple for an artist who pursued naturalism: some clients were receptive to novelty but others tied his hands with ecclesiastical restrictions. Yet the difficulties did not derive solely from his work: his private life was becoming more complicated because of his violent and profligate behaviour: he was involved in arguments and brawls with friends and colleagues, so that his name appeared in a number of legal actions. At the end of August 1603, he quarrelled with Giovanni Baglione and had to stand trial; this ended on September 25 with Caravaggio being released from prison through the intercession and guarantee of the French ambassador.

■ Portrait of Giovanni Baglione in an anonymous engraving of the 17th century. Among the earliest biographers of Caravaggio, Baglione was a great rival and critic of the artist. However, apart from occasional bursts of malice, his account of Caravaggio's life was fairly objective.

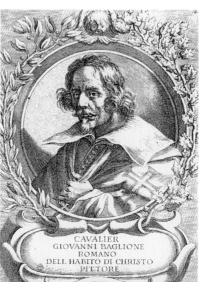

■ This document is from the lawsuit brought by Baglione against the architect Onorio Longhi and the painters Caravaggio, Orazio Gentileschi, and Filippo Trisegni for having libelled him through scurrilous and defamatory verses.

■ Caravaggio, *The Death of the Virgin*, 1605–06, Musée du Louvre, Paris. "Because in the person of the Madonna he has portrayed one of his whores" or "because he has indecorously done a bloated Madonna with exposed legs", the commission from the Carmelites of Santa Maria in Trastevere was rejected and sold.

■ Caravaggio, *Madonna of the Serpent* or *Madonna of the Palafrenieri*, 1605, Galleria Borghese, Rome. The painting for the Palafrenieri in St Peter's basilica remained for under a month on the altar there. Transferred to the church of the Confraternita di Sant'Anna, it was then sold for 100 scudi to Cardinal Borghese.

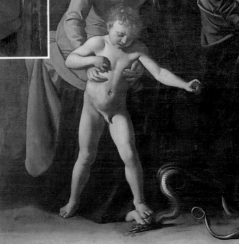

Rubens in Rome

■ Peter Paul Rubens, *Adoration of the Shepherds* (or *Night*), 1608, Chiesa di San Filippo Neri, Fermo. This successful Italian work pays homage to Correggio and the 16th-century Emilians.

Peter Paul Rubens, at the age of 23, left Antwerp for Italy in order "to study the works of the ancient and modern masters and to perfect himself by their example". After brief stays in Venice and Genoa, he came to Rome in the summer of 1601 under the patronage of Cardinal Montalto, to whom he had been recommended by the duke of Mantua. Being in Rome gave Rubens the opportunity to study Raphael and Michelangelo, as well as the frescos and drawings of Annibale Carracci: he was struck by the latter's strength of design, both in his studies of the human figure and his portrayal of people in their daily occupations. In the light of his Carracci experience, the Flemish artist recognized that Rome could offer a wealth of old and new material, which he drew and copied continuously, converting it into "Baroque" form. He linked this with Titianesque color, admired in Venice, and Caravaggesque chiaroscuro. The synthesis of these Italian modes was to be revealed in his great Roman and Genoese works. However, Rubens had little admiration for the figurative composition of Caravaggio, whose work he had come to know already during his first stay in Rome, and he showed no interest in studying the paintings in greater depth, because the Lombard painter did not regard drawing as a creative phase. Nevertheless, like other northern artists, Rubens was fascinated by the power of Caravaggio's religious paintings, so much so that he purchased for the duke of Mantua the *Death of the Virgin*, which had been turned down by the clients.

■ During his first visit to Italy, Rubens was in Rome from the summer of 1601 to the spring of 1602. Returning to the capital in 1605, he obtained permission to make his home there for some time.

The lure of Rome for foreign painters

Since the 15th century, travelling abroad was the distinctive mark of the avant-garde artist. At the beginning of the 17th century, Italy was still the land that harboured the most advanced ideas and played a pre-eminent cultural role in Europe. The journey to Rome, for the sake of its antique remains and its artistic movements, was a fundamental step in the training of many foreigners, some of whom chose to make their home in the city permanently. In Rome, capital of the Christian world until 1650, decisions were being made for the future of European art.

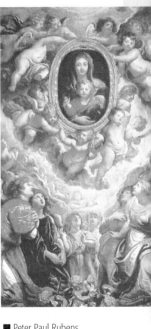

■ Peter Paul Rubens, *Madonna of the Vallicella Adored by Angels, 1608,* Chiesa di Santa Maria in Vallicella, Rome. For his second version of the altarpiece, Rubens chose to work directly inside the church in order to avoid any possible difficulties that might arise as a result of reflections.

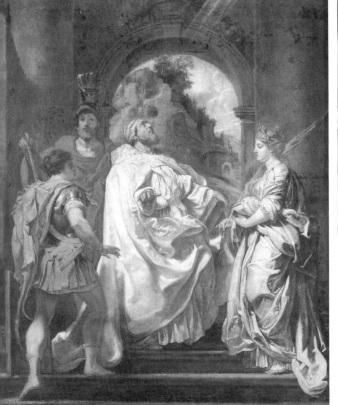

■ Peter Paul Rubens, *SS Gregory, Domitilla, Maurice, Papias, Nereus and Achilleus,* 1606, Staatliche Museen, Berlin. Rubens made a sketch in much bigger dimensions than that of a normal model in order to demonstrate his ability to the Oratorians.

The cycle of the Cerasi Chapel

Caravaggio delivered his next great public commission, the two canvases *The Martyrdom of St Peter* and *The Conversion of St Paul* for the Cerasi Chapel of Santa Maria del Popolo, five months late. The heirs of the client, the confraternity of the hospital of the Consolation, paid the artist 100 scudi less than the price agreed. Initially, the works were to have been done in cypress wood but, instead, they were done on canvas. These were new versions, the orignal attempts having been refused. It is unclear whether the changes were made on the insistence of Cerasi prior to his death, by his heirs, or even by Caravaggio himself, possibly to adapt the paintings to the "Bolognese" style, like that of the work by Annibale Carracci later installed in the same chapel. The contract stipulated that he should paint "ex sua inventione et ingenio", but demanded that he should first submit "models", of which no traces remain. The artist took account of the surrounding architecture, and the foreshortened structure was conceived from the viewpoint of a moving spectator.

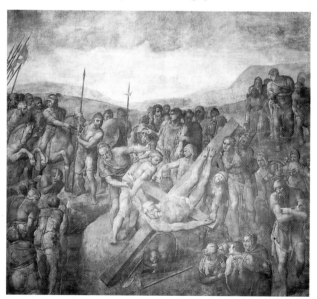

■ Michelangelo, *Crucifixion of St Peter*, c.1545, Pauline Chapel, Rome. This work had a powerful impact on Caravaggio.

■ Caravaggio, *Crucifixion of St Peter,* 1601, Chiesa di Santa Maria del Popolo, Rome. Although following traditional iconography, this scene was interpreted by Caravaggio with extreme realism, clear inthe lifting of the altar cross with a rope and the use of Peter's body as a lever. He restricts the event to the essential figures of martyr and executioner, large in scale so as to emphasize their significance.

■ Santa Maria del Popolo, Rome. Cerasi bought the chapel to the left of the altar for his family tomb. For the altar itself he also ordered from Carracci a painting of the *Assumption.*

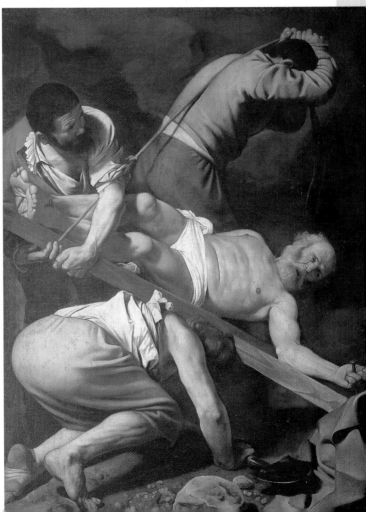

■ Guido Reni, *Meeting of Saints Peter and Paul,* Pinacoteca di Brera, Milan. Here, Caravaggio's influence is evident.

Conversion of St Paul

With its spareness and force of vision, this painting, created for the Cerasi Chapel of the church of Santa Maria del Popolo, Rome, represents a complete transformation of the original version, which was refused.

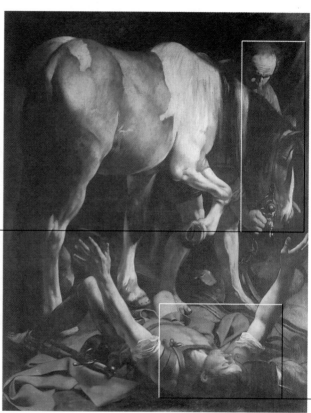

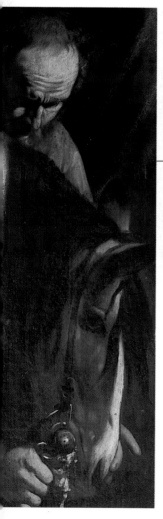

■ The background of the scene has an everyday character about it, with an ageing groom soothing the terrified horse. The secular context seems to heighten the exceptional nature of the sacred event. It is possible to read more into this: the groom may be a symbol of reason and the animal an emblem of sin. The two figures may therefore help to illustrate Grace in the contrast between the light of salvation and the shadow of sin.

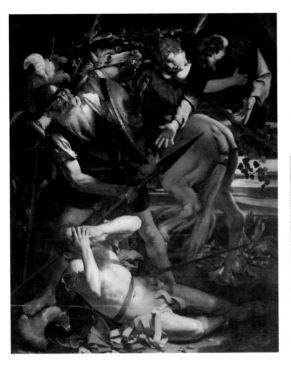

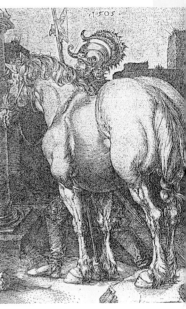

■ Albrecht Dürer, *The Large Horse*, engraving, 1505. An iconographic precedent for Caravaggio who, however, gave the animal an exceptional figurative role in his painting, devoting to it about one half of the overall space.

■ The rejected version, now in the Odescalchi Collection, showed the conversion of Paul of Tarsus, persecutor of the Christians, on the road to Damascus, following the appearance of Jesus, who dazzles him with light. The rejection was perhaps due to the apparition's physicality, which negates the contrast between human and divine.

■ In this detail, Saul is blinded by the great beam of light, but the image of Christ who is revealed to him is not shown. Saul, who does not know and cannot see, is possibly inspired by the philosophy of the contemporary Giordano Bruno, whereby man has no opportunity of seeing God. The painter's technique has the effect of causing the light that falls on the objects to "emerge" from the dark recesses of the background.

A trip to Genoa

A̲fter a dispute in which he wounded the notary Pasqualone, Caravaggio sought safety in Genoa, where his presence is documented from August 6, 1605. The flight lasted about one month; having obtained a judicial pardon from the notary, the painter was allowed to return to Rome. In Genoa, he was helped by the same people who would later offer him hospitality in Palermo – Ascanio Sforza and Filippo Colonna, the latter a nephew of Ascanio and the marchioness of Caravaggio. During his visit, he was approached by Prince Marcantonio Doria, who received him as his guest and tried to entrust him with the fresco decoration of the loggia of his home at Sampierdarena for a fee of 6000 scudi. The artist refused, perhaps because he knew he was there only temporarily or possibly because he did not wish to use the fresco technique, which he disliked (for this reason, Del Monte called him "an extremely odd person"). Prince Doria had better luck in due course, when Caravaggio painted a canvas for him depicting the *Martyrdom of St Ursula* (1610). However, the painter's stay in Genoa was so brief that he had no time to get acquainted with local art trends, although some of his followers subsequently spent time in the Ligurian capital, where there was widespread admiration for northern artists.

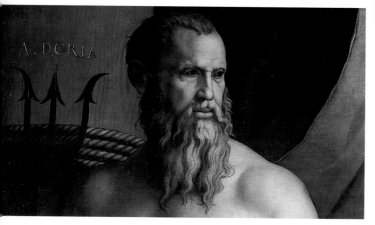

■ Bronzino, *Portrait of Andrea Doria*, detail, 1531, Pinacoteca di Brera, Milan. Depicted here in the likeness of a sea god, Andrea Doria was a generous patron of the arts. In 1528, he commissioned Perin del Vaga to decorate his villa at Fassolo, leading the way towards art collection as a sign of power and wealth.

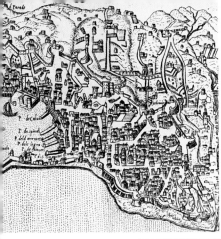

■ The constitutions of 1528 and 1576 helped bring stability to the State of Genoa. All public offices were assigned to the nobility, who competed to decorate the city palaces and churches, inspired by the style of Mannerism. Genoa, still locked within its 14th-century boundaries, soon changed its appearance.

■ Caravaggio, *Ecce Homo*, 1604-6, Galleria di Palazzo Bianco, Genoa. Monsignor Massimi entrusted the same subject to three painters, Cigoli, Passignano, and Caravaggio. Here, there is no contrast of good and evil and no signs of violence on the figure of Christ; instead, the painter concentrates on a sense of inner suffering.

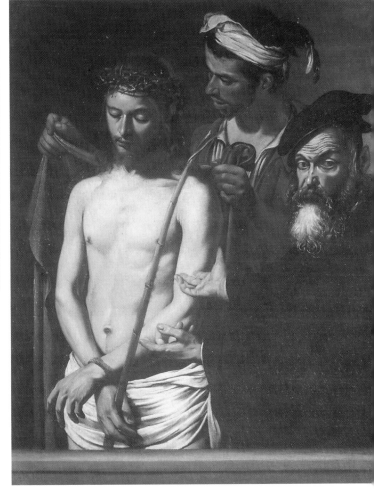

■ Luca Cambiaso, *Nativity*, detail, after 1550, Pinacoteca di Brera, Milan. A Ligurian painter of the late 16th century, Cambiaso was associated with notions of severe monumentality and arid pragmatism. However, occasionally, as here, his intuition produced results that were to be developed by painters of the next generation.

BACKGROUND

The debate
on decorum

At the conclusion of the Council of Trent, one of the most discussed subjects was that of decorum in sacred art. Apart from the various comments and treatises that were published at the time, what emerged most clearly from the discussion of December 3 and 4, 1563, in the 25th session of the council, was the need to paint with propriety and dignity. In practice, painters were requested to refrain from portraying inappropriate images calculated to upset the minds of ordinary observers, the ranks of the simple faithful, but to raise them to the greatness of the Church triumphant, a greatness that transcended the human and offered consolation from the grievous miseries of earthly existence. The Church tended, initially at least, to maintain a strict attitude in this regard; later, however, particular religious orders, such as the Philippines and the Oratorians, and certain clerics, such as Federico Borromeo, elaborated independently upon the notions expressed by the council, modifying its imposed directives.

■ Dirty feet are evident in the *Crucifixion of St Peter:* this was not an outrage to decency but, as indicated by Borromeo in his *De pictura Sacra,* a sign of obedience. Alternatively, in accordance with the New Testament, it might signify the need for purification.

■ In Rome, although less strict than Milan, adjustments were made to paintings judged to be improper: thus Pietro da Cortona covered the nudes in Michelangelo's Sistine Chapel.

■ Giovanni Battista Crespi, *Altarpiece of the Madonna of the Rosary,* c.1618, Pinacoteca di Brera, Milan. The celestial hierarchy is reflected in the details.

■ Carlo Buzzi, *St Charles Institutes the School of Christian Doctrine,* 1604, Milan Cathedral. To reinforce orthodoxy, Carlo Borromeo created schools for the faithful.

■ In this detail from the *Rest on the Flight into Egypt* by Caravaggio (Galleria Doria Pamphili, Rome), the bare feet of St Joseph are a sign of his humility and simplicity.

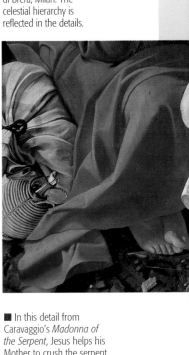

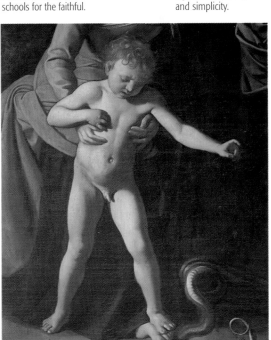

■ In this detail from Caravaggio's *Madonna of the Serpent,* Jesus helps his Mother to crush the serpent. The child is wholly human, innocently and realistically naked; it was for this reason that the work was removed from the altar of St Peter's.

Madonna of the Pilgrims

Also called the *Madonna of Loreto*, this was painted between 1604 and 1606 for the Cavalletti Chapel in the church of Sant'Agostino, Rome. The scene, with its innovative iconography, shows the two elders paying homage at the foot of the shrine.

■ The clever use of light gives the sculptural block of the sacred figures of Virgin and Child a vital sense of flesh and blood. The smooth skin and silky fabrics form a contrast with the rough-skinned, raggedly dressed pilgrims. The chromatic uniformity of the light is a unique feature.

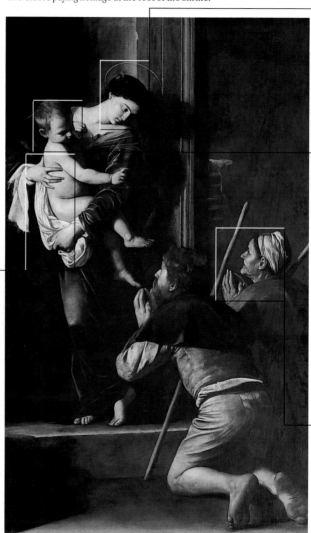

■ The image of the Madonna retains all her ideal nobility in the smooth, delicate rendering of the face. The Virgin is more than ever an intermediary between the believer and the holy Mother Church. The model was Lena, whose frequent sittings aroused the jealousy of the notary Pasqualone, which led to Caravaggio's subsequent flight to Genoa.

■ The expression of the Child on the arm of his Mother, who looks down on the two kneeling pilgrims with an air of diffidence (Caravaggio placed the two sacred figures on a step, as in a niche) is both powerfully realistic and immediately comprehensible.

■ The elderly female pilgrim is rendered with great humanity. She would have been familiar to the painter, both from the pilgrimages to Rome during Holy Year and from observations in Caravaggio. To Baglione, the dirty, ragged bonnet was yet another example of impropriety.

The development of collections

In the 16th and 17th centuries, the needs and motivations of the collecting habit changed; the cabinet of humanist culture disappeared and the gallery, which it both opposed and complemented, was born. The specialized cabinet had been created for a small, functional space and its use encouraged the values of introspection and intellectual and aesthetic meditation that were typical of 15th-century culture. The gallery represented its continuation and logical development and, with its broader scope and improved facilities, brought about a fuller involvement with the public at large. It conferred kudos on the owner or donor and it conserved and tastefully displayed artistic treasures and family achievements. The gallery concept spread widely through Italy, but attained its most enduring and spectacular application in Rome, where by the end of the 16th century it came to grace royal and noble residences, affirming and preserving Baroque culture. The taste for collecting established the basic requisites for the development of the history of art and for the invention of various graphic techniques. In the 17th century, progress was made towards a new form of criticism that was founded on historical perspective, analysis, and interpretation. Knowledge of art acquired a new connotation, while the traditional images of client and artist underwent modification. The artist finally managed to throw off completely the label of "mechanic" and gradually gained a greater measure of social and intellectual recognition.

■ Gaspar Dughet, *Landscape with Rinaldo and Armida*, Galleria Corsini, Rome. The development of the public collection went hand-in-hand with the definition of "genres", which met with great success in the 16th and 17th centuries. The "Arcadian landscape", mingling classical and naturalistic detail, was especially popular.

■ Annibale Carracci, *Flight into Egypt*, 1604, Galleria Borghese, Rome. By the end of the century, this landscape lunette was already regarded as more suitable for a palace than a private chapel.

■ Giuseppe Magni, *View of a Wall of the Tribune*, second half of 17th century, Galleria degli Uffizi, Florence. The collection of ancient and modern works of art and the exhibition of them in a gallery was an important indication of the wealth and status of the customer.

■ Claude Lorrain, *Mercury and Argus*, 1645, detail, Galleria Doria Pamphili, Rome. The much admired French artist successfully blended northern and Bolognese elements.

■ Domenichino, *Landscape with Flight into Egypt*, 1621–23, Musée du Louvre, Paris. This Bolognese painter was notable for his unrealistic landscapes of ideal classical beauty.

■ Aniello Falcone, *Battle of Spanish Knights*, after 1635, Collezione Catello, Naples. Many collectors of genre paintings were prepared to devote a great deal of space to historical battle scenes.

The painter Aniello Falcone was a specialist in this genre, especially gifted in conveying a brilliant, incisive effect of luminosity. In his work, the historical episode shed its significance as mere chronicle.

The study of states of mind

The continual attempt of Caravaggio to represent reality coincided with his need to get to the heart of things, to paint subjects as they appeared, striving not for perfection but for truth. Even more important, however, was his concern to express the human mind, to subject it to examination and analysis in a manner that could almost be termed psychological. This profound tendency was a consequence of his study of naturalism and stemmed from his Lombard upbringing. Caravaggio easily absorbed the keen interest in "real" painting that had developed steadily in 16th-century Lombardy and he bore in mind earlier works that had sought to penetrate the minds of the human subjects depicted. Like Leonardo, he studied the movements and spontaneous reactions of people so as to convey their diversity and peculiarities in a manner far removed from the captiousness that so often pervaded Mannerism. This, from the start, was the distinguishing element of Caravaggio's scenes and characters. Only later did it merge consistently with the allegorical and symbolic meaning that was the fruit of the artist's familiarity with more elegant cultural environments.

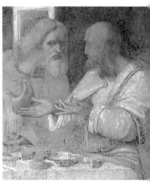

■ Leonardo da Vinci, *Last Supper*, detail, 1495–98, refectory of Santa Maria delle Grazie, Milan. According to Vasari's account of his life, Leonardo was the first artist to concern himself with expressing the feelings of the people he depicted.

■ The heartfelt grief of a woman of the people, as shown in this detail from the *Death of the Virgin* by Caravaggio (1605–06, Musée du Louvre, Paris), exemplifies the painter's understanding of human reactions to tragedy.

■ The knowing smile on the face of the young gypsy woman in this detail from *The Fortune Teller* (c.1594–95, Musei Capitolini, Rome) registers both curiosity and reassurance as she prepares to ensnare and gain the confidence of her unsuspecting victim.

■ Caravaggio, *The Cardsharps,* c.1594–95 Wadsworth Atheneum, Hartford, Connecticut. In this atmospheric painting, the duped young man calmly chooses which card to play, while the expert gambler signals the next move to his more timorous young accomplice.

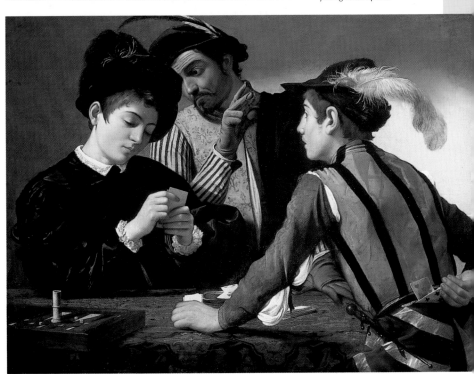

St Jerome

The *St Jerome* of the Borghese Gallery dates from the late Roman period. The iconography seems to reflect both the artist's moment of spirituality and the importance of the saint in the Counter-Reformation.

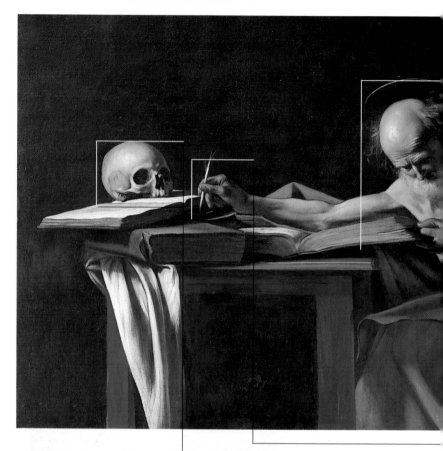

■ The skull, a traditional iconographic attribute of St Jerome associated with the concept of *memento mori*, rests on a pile of books. These are arranged on different levels, with the effect of creating another element of spatial depth.

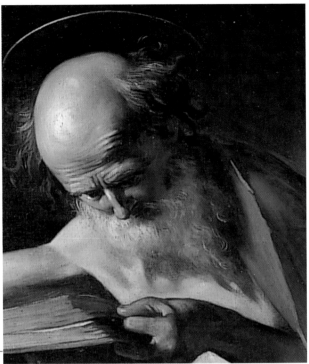

■ The vivid lighting of the saint's bald head gives it prominence in the image. The inventive expedient of the halo (infrequent among Caravaggio's sacred images) creates the effect of spatial depth against a distinct background. St Jerome is no longer an intellectual humanist but a man, inspired by God.

■ The hand of the saint reaches out to dip the pen into a distant inkwell. The unnatural prolongation of the arm links the inanimate nature of the skull and books with the living reality of the saint, all on the same plane.

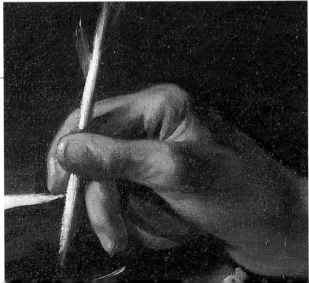

The new religious orders

■ Carlo Dolci, *San Filippo Neri*, 1645, Galleria degli Uffizi, Florence. Neri (1515–1622) wrote a set of rules based upon humility, discipline, study and, above all, serene good humor.

In the latter half of the 16th century, on the initiative of various high-ranking individuals, a number of new religious orders and communities were widely established. The Order of the Society of Jesus (the Jesuits) was founded in 1540, even before the convocation of the Council of Trent, as a reaction against Lutheran reform. The founder, St Ignatius of Loyola, was a Spaniard: the impetus for the revision of religious thinking and the arousal of the devout to mend their faith came from a land where the Church had always struggled to remain united against the infidel. Ignatius instituted a militant rule and wrote spiritual exercises in which ascetic practice was not an end in itself but a means of strengthening character. Theologically, he favored conservatism and a formal rigidity that accorded wholly with the spirit of the Counter-Reformation and to some extent helped to bring it about. After the Council of Trent, the need became ever more urgent to found religious groups that could give certainty to the disoriented faithful. Thus were born orders dedicated to charitable works: St Philip Neri, in 1575, founded the community of the Oratorians, which followed the precepts of previous groups of regular clergy (Theatines, Somaschi, and Barnabites) but was closer to the Jesuits in its preoccupation with the education of children and the promotion of culture.

■ *Meeting of the Blessed Philip Neri and the Blessed Ignatius Loyola*, engraving by Peter Paul Rubens and Jean-Baptiste Barbé, Private Collection, Rome.

■ Stefano della Bella, *Procession of the Blessed Sacrament*, etching, first half of 17th century. The Church was eager to encourage processions.

■ *Altar of St Ignatius*, Chiesa del Gesù, Rome. The altar where St Ignatius di Loyola was buried was designed by Andrea Pozzo. With its use of priceless materials, it involved the work of a hundred or so artists.

■ Il Duchino, *St Charles Founds the Monastery of the Capuchins and the Orders of the Virgins of St Ursula and St Anne*, 1603, Milan Cathedral. Carlo Borromeo was generous toward new orders.

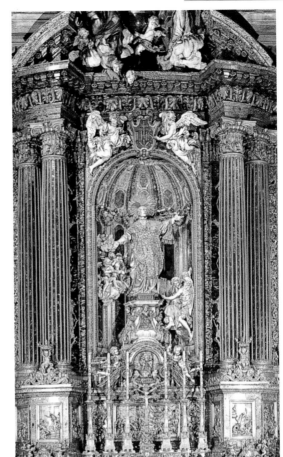

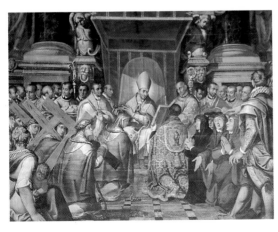

■ Baciccia, *Triumph of the Name of Jesus*, 1679, vault of the Chiesa del Gesù, Rome. Effective use of color and chiaroscuro produce a breakthrough effect in the "expulsion" of the figures towards heaven.

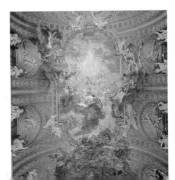

The Deposition of Christ

Now in the Vatican Museums, *The Deposition of Christ* was painted between 1602 and 1604, for the altar of the second chapel on the right in the Chiesa Nuova. The church was rebuilt in the late 16th century for Philip Neri's Oratorians.

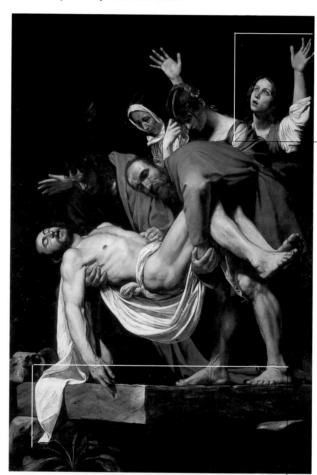

■ The detail of the stone upon which the body of Jesus is laid is rendered with exceptional skill. The slab juts out at a slant, like the pedestal of a complex sculptural group and is even closer to the spectator than to the main action.

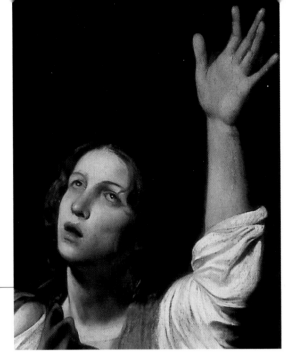

■ The eloquent gesture of Mary Cleophas, who brings up the rear of the funeral cortège, conveys a powerful expression of grief, like a voiceless cry.

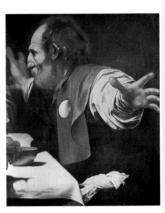

■ Another expressive gesture, dating from a few years earlier than *The Deposition*, can be seen in this detail from the first version of the *Supper at Emmaus* (1596, National Gallery, London). The outstretched arms of the disciple create an extraordinary effect of spatial depth.

■ In this older source from the Renaissance, a 15th-century engraving by Mantegna or his school, a similar raised arm gesture by Mary Magdalen also expresses grief.

■ Caravaggio, *Supper at Emmaus*, detail, c.1596, National Gallery, London. This detail seems to leap out of the painting, creating a close sense of involvement between spectator and action.

The first Caravaggisti

■ Giulio Cesare Procaccini, Cerano, Morazzone, *Martyrdom of Sta Seconda and Sta Rufina*, c.1615–20, Pinacoteca di Brera, Milan. The composition of this painting is reminiscent of that of Caravaggio's *Martyrdom of St Matthew* (1600, San Luigi dei Francesi, Rome), although it lacks its deep sense of tragic insight.

Very soon after the appearance of his first public works with their extraordinary innovations, Caravaggio had founded a school. A band of so-called Caravaggisti quickly formed, based in the places most frequented by the painter. Among the first were Baglione and Gentileschi, artists older than himself; the former went through a Caravaggesque phase during his works in Santa Cecilia, which brought him some fortune when he was assigned the task of making an altarpiece with the Resurrection of Christ for the lateral nave of the church of the Gesù. Baglione learned from Caravaggio how to render light with richly contrasted effects of chiaroscuro. More independent was his contemporary, Gentileschi, whose assumption of Caravaggio's stylistic methods and forms came in stages, so that in his works from the first decade of the century there were still elements of late Mannerism, which he discarded only after Caravaggio's flight from Rome. The flood of imitations, however, was not confined to the Roman artistic milieu and those centres where the painter had been active: the inclination to experiment with the great novelties of luminism and tenebrism, with new forms and subjects, extended to other centres in Italy and was also to affect a number of foreign artists.

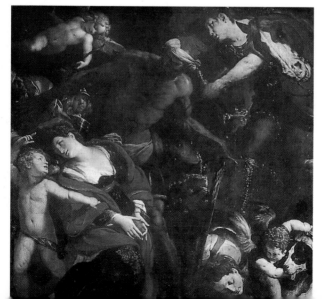

■ Bartolomeo Manfredi, *Chastisement of Cupid*, c.1610–20, Art Institute of Chicago. By the time the demand for new works by the Caravaggisti had almost dried up, the Lombard style was being revived, even for non-genre scenes. Here, it is applied successfully to new subjects by Bartolomeo Manfredi.

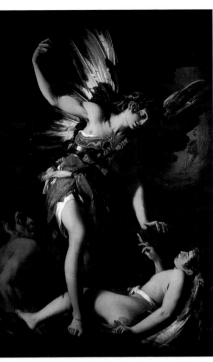

■ Giovanni Baglione, *Sacred Love and Profane Love*, 1602, Galleria Nazionale di Arte Antica, Rome. This work represents the most significant creation of the artist's Caravaggesque period. From the law proceedings of 1603, we know that the work did not please Caravaggio, who was angered by the fact that a rival should successfully claim credit for the innovations he had introduced.

■ Orazio Gentileschi, *SS Cecilia, Tiburtius and Valerian*, c.1605–07, Pinacoteca di Brera, Milan. In an altarpiece of late Mannerist style, Gentileschi uses Caravaggio's naturalism to create the tactile quality of the clothing, and accentuates the luminous effect with the background lighting of the figure at the door.

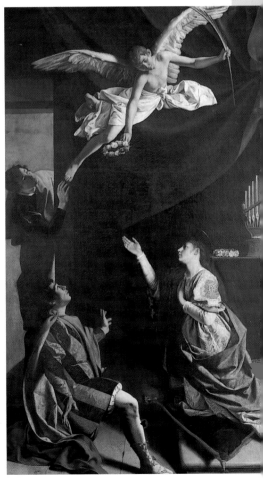

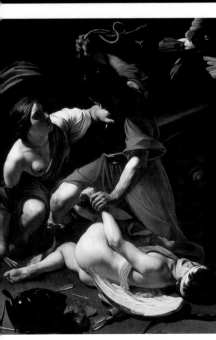

Problems of a violent character

Caravaggio's violent nature was no mere legend, as a number of legal proceedings attest. From the end of May 1600, his name appeared in the archive of the Tribunal of the State of Rome and, apart from one case in which he featured as mediator in a lawsuit, he was invariably associated with brawls, assaults, disturbances of the public peace, causing injuries, carrying unlawful weapons, and other outrages of all kinds (from hurling insults to plates of artichokes). The earliest biographies relate that even his trip to Rome arose from a conviction or an assault. However, it was in Rome that Caravaggio's argumentative nature was most convincingly demonstrated, with reports of quarrels, lawsuits, prison sentences, and flights. He usually managed to get away with his misdeeds, never admitted, often thanks to patrons who stood guarantee for him. Things did not turn out well, however, and in 1606 the most serious crime occurred: in a brawl or perhaps a duel in the Campo Marzio, probably caused by an alleged cheating incident in a game of rackets (apparently a bet of 1000 scudi was at stake), the painter mortally wounded the head of a rival gang, Ranuccio Tomassino da Terni. His guilt was proved, he fled the sentence, and thus began the exile that was to keep him far away from Rome for the rest of his life.

■ Jaques Callot, *Scene of a Duel.* The duel in which Caravaggio killed a man was not his only one. In 1605, recovering from a sword wound, he admitted to having provoked it.

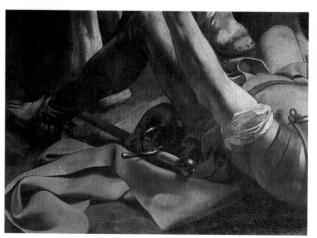

■ In this detail from the *Conversion of St Paul* (c.1601, Santa Maria del Popolo, Rome), Saul's sword is rendered a useless weapon, no more than a reminder of the persecutor's past life .

■ In this detail from the *Calling of St Matthew*, (1600, San Luigi dei Francesi, Rome), a sword is worn on the hip of an elegant young man. Because of the threat of armed criminals in 17th-century Rome, it was necessary, though at risk of arrest, to carry a weapon. In May 1605, Caravaggio was arrested after being caught unlawfully carrying a weapon.

■ *Marzio Colonna, Duke of Zagarolo by Domenico de' Santis*, "Columnesium Procerum", 1675, Rome. Through his ancient links with the Colonna family, Caravaggio found refuge when he fled Rome, either at Palestrina, Paliano, or Zagarolo.

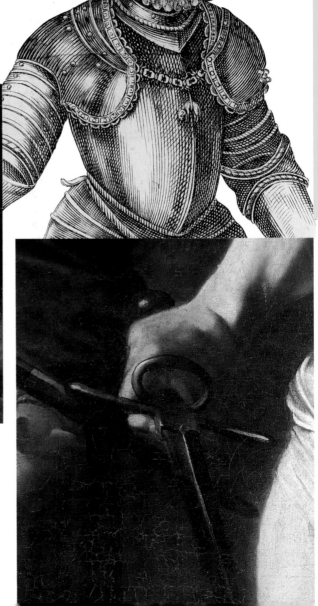

■ The sword that kills St Matthew, pictured in this detail from the *Martyrdom of St Matthew* (San Luigi dei Francesi, Rome), is skilfully described by the artist, who shows his familiarity with weapons.

Supper at Emmaus

The version of the *Supper at Emmaus* in the Pinacoteca di Brera in Milan was completed in the first months of the artist's flight from Rome. The use of light and the positioning of the figures are typical of the mature Caravaggio.

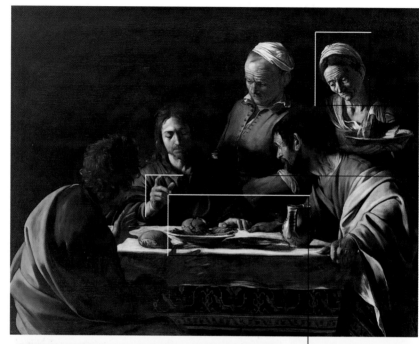

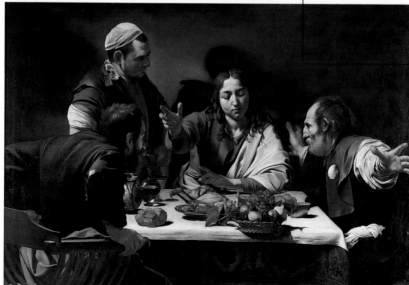

■ The elderly serving woman, not an essential character in the Gospel story, has a particularly expressive face and her meditative air serves a precise function. Recognizing Christ's gesture, she seems sadly to be conjuring up the recollection of something she once knew but which is now forgotten and remote.

■ This detail of St Anne from the *Madonna dei Palafrenieri* (Galleria Borghese, Rome) reveals the same style of modelling as that of the Roman period. However, the lighting gives a greater sense of emphasis in the new context.

■ The hand of Jesus, raised in blessing and through which he makes himself known to his disciples, is eloquently painted. In fact, the act of blessing preceded the breaking of bread, but here it is already broken, as though to prolong the sublime gesture.

■ The still life on the white tablecloth, reduced to its essentials so that each object stands out more clearly, is the last that Caravaggio painted. The bread and the wine allude to the Eucharist, to which the artist adds a modest plate of salad, reflecting the humble inn surroundings.

■ Caravaggio, *Supper at Emmaus*, c.1696, National Gallery, London. Painted ten years earlier, the details in this version are richer and more varied, such as the exaggerated gestures of surprise, the air of naturalism, the well-stocked table, and the revival of ancient iconography in the beardless Christ.

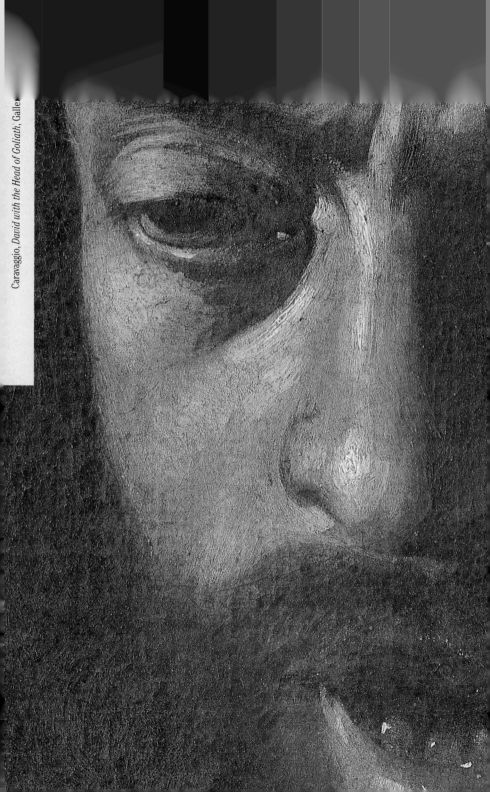

Naples, a Mediterranean capital

As the 17th century began, Naples, the Spanish capital until 1503, changed its appearance and its situation as a result of public, private, civic, and religious building projects. Particularly after the viceroyalty of Don Pedro of Toledo, the ancient Mediterranean capital, which had previously played an indifferent civic and cultural role, was transformed into a dynamic city receptive to the circulation of productive ideas and experiences. The king's strongly centralized government attracted the aristocratic classes to a capital, which became such a focal point of the kingdom's wealth that the professional and merchant classes also chose to live there. Furthermore, Naples was a city that tolerated many forms of ecclesiastical organization, open to the development of new ideas and to scientific experiment. As regular amounts of money flowed in to be earmarked, for reasons of private prestige and civic pride, for the founding, enlarging, and modernizing of places of worship and entertainment, Naples also became an active centre of the figurative arts. Whatever the form or approach, these all reflected the same wide-ranging confidence in cultural values and objectives.

■ One of the problems confronting the city was the need to rid itself of the risk of pirate attacks.

■ *The Viceroy Juan Alfonso Pimentel de Herrera*, engraving by Domenico A. Parrino, 1692, "Teatro Eroico", Naples. The authority of the Spanish viceroy was absolute, despite the control of parliament.

■ Early in 1607, the viceroy, faced with a serious food shortage, taxed fruit and rationed bread, but only succeeded in boosting supplies of expensive food that people could not afford.

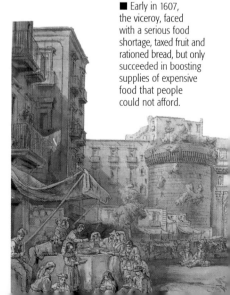

■ Among the most populous cities in Europe, with about 270,000 inhabitants, Neapolitans hated the Spaniards, but did not attempt to expel them, in the hope of gaining more effective viceroys. Thus, despite several insurrections, the city remained loyal to the emperor.

■ The Maschio Angioino was built by King Charles I of Angiò, rebuilt by Alfonso I of Aragon, and fortified in 1509–37 with modern Spanish towers. Charles V lived there in 1535 on his return from his Tunis campaign and, in 1547, it was attacked by rebels against the Inquisition tribunal.

■ Onorio Palumbo and Didier Barra, *St Januarius Intercedes with the Blessed Trinity for the Salvation of Naples*, detail, c.1652, Arciconfraternita della Trinità dei Pellegrini, Naples. This view of the city dates from a few years after Caravaggio's stay there.

Caravaggio's first encounter with Naples

Caravaggio arrived in Naples, the only city that could offer him the opportunity of important work, prior to September 1606, thanks to money sent him by Ottavio Costa who had bought the *Supper at Emmaus*. He was certainly helped, too, by Marzio Colonna, who had links with the capital and had been High Constable in 1601. Caravaggio remained there for nine or ten months, keeping very busy, as attested, among other documents, by statements issued by the banks of St Eligio and St Spirito. Nicolo Radulovic was the first to approach the painter, which may have led to his first private commission in Naples, the *Madonna of the Rosary* (Kunsthistorisches Museum, Vienna). This was wholly Neapolitan both in style and choice of models. Soon after, for the Governors of the Pio Monte de Misericordia, Caravaggio painted the *Madonna of Mercy*, completed in December, and followed this with his *Flagellation*. Next, he produced *David*, another *Flagellation*, and perhaps *Salome*, as well as the *Crucifixion of St Andrew*, which the viceroy would bring to Spain in 1610. The painter's stay in Naples was quite brief, but proved so productive that it had a clear influence on the local art, helping direct it towards the more modern painting style of the 17th century.

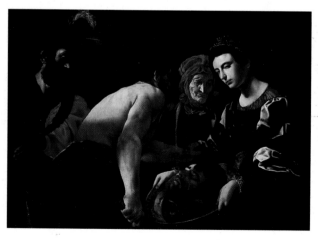

■ Battistello Caracciolo, *Salome*, c.1617, Galleria degli Uffizi, Florence. In this tragic scene by the leading Neapolitan artist Caracciolo, there is no sense of drama, nor any attempt at a representation of emotions or states of mind. Instead, this is a discerning study of forms and masses.

■ Caravaggio, *Flagellation*, 1607, Musei e Gallerie di Capodimonte, Naples. Here, Caravaggio contrasts the hard physicality of the gaolers with the divinity of the Redeemer's body.

■ Giovanni Battista Lama, *Entombment*, c.1580, SS Severino e Sossio, Naples. The "devotional" tendency of 16th-century southern painting encouraged a realism conveyed in drab tones.

■ Battistello Caracciolo, *Flight into Egypt,* c.1617., Musei e Gallerie di Capodimonte, Naples. After Caravaggio's arrival in Naples, Caracciolo adopted a new, if somewhat cold and academic, language of naturalism. This is clear in his use of light and his stark definition of volumes, as well as his avoidance of pathos.

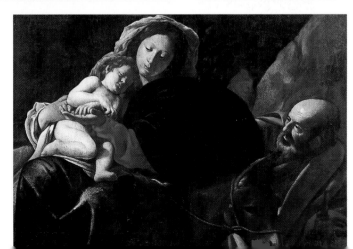

Madonna of the Rosary

Now in the Kunsthistorisches Museum in Vienna, this crowded composition was one of Caravaggio's first Neapolitan works, dating from about 1606–7. It may have been commissioned by Marzio Colonna.

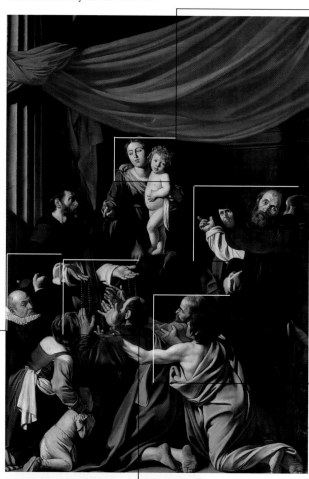

■ The unknown donor depicted in the painting, who turns boldly toward the observer, may be indentified as the merchant of Ragusa, Nicolò Radulovic, thought by some to have actually commissioned the work.

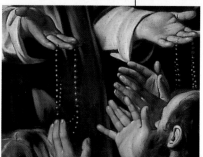

■ The astonishing combination of so many different hands, which express a diversity of feelings, seems to pervade the painting like a luminous act of levitation.

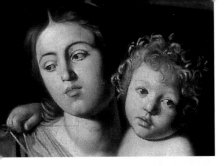

■ The geometrical centre of the whole composition is the Child. The Mother who embraces him, making a particular gesture towards St Dominic, seems to wish all eyes to be turned on herself, so that she too becomes central to the scene as the source of Grace. Although respecting the tradition of the altarpiece, the painter freely focuses attention on new details of symbolic significance.

■ Pointing to the Madonna, St Peter the martyr, pointing to the Madonna, looks squarely at the observer, clearly revealing the wound on his head, sign of his martyrdom. His figure seems to acquire a special significance in the context of the conflicts of the Counter-Reformation, for he himself was an inquisitor and was revered as patron of the Holy Inquisition.

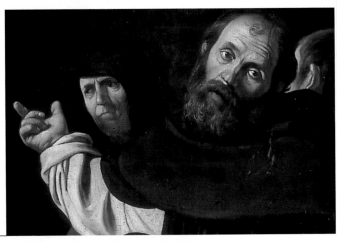

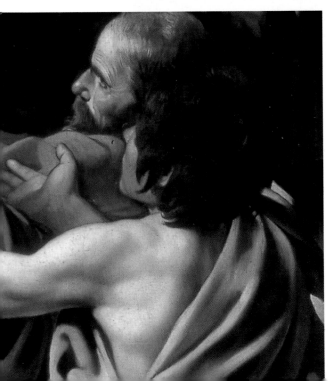

■ Caravaggio gives his characters a sculptural quality through an interplay of lighting that is remarkably diffuse and enveloping. The whole composition turns on the contrast between humble human reality and ideal divine majesty.

1606-1610

The Seven Works of Mercy

This canvas was commissioned by the Governors of the Pio Monte della Misericordia for the high altar of the confraternity's church. Completed in 1606, the work earned the painter the generous sum of 470 ducats.

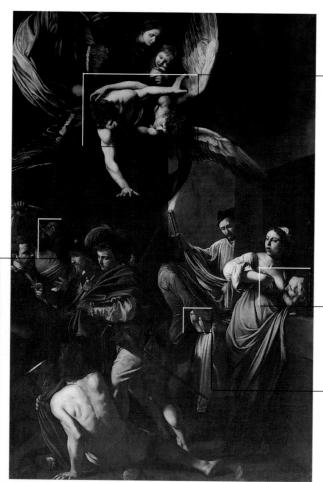

■ Giving drink to the thirsty: Samson in the desert of Lehi uses his weapon as a receptacle for the water that the Lord has caused to gush out for him.

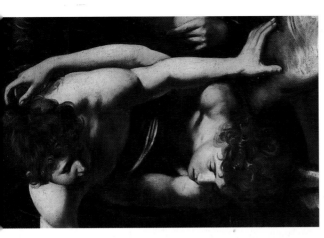

■ "Acrobatic" angels create a vortex as the sign of celestial presence. They serve both to transport and restrain the Virgin and Child, so that the concentration of the observer is drawn to the earthly representation of the seven works. In an earlier version, Caravaggio gave this group less space. The effect of the light is very beautiful and creates an unstable equilibrium.

■ The episode taken from Valerius Maximus, in which the aged Cimon in prison is suckled by his daughter Pero, unites two of the most profound and spiritual acts of mercy: "visiting the imprisoned" and "feeding the hungry". This is in accordance with the traditional image of so-called "caritas romana".

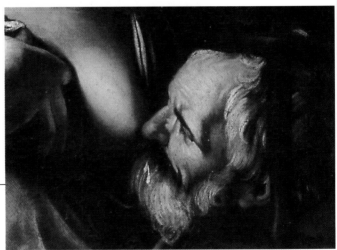

■ Representing the work of mercy of "burying the dead" are the feet of the corpse, which are illuminated by a band of light. In his customary manner, Caravaggio introduces more than one light source, using artificial light to allow the figures to emerge from the darkness.

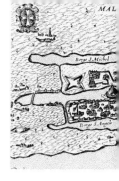

Malta, pride of the knights

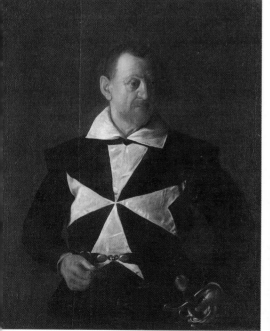

■ Caravaggio, *Portrait of a Knight of Malta* (possibly Alof de Wignacourt), 1608, Galleria Palatina, Florence. The silken cross shows great technical virtuosity. This is possibly the artist's last work done in Malta.

When Caravaggio reached Malta in 1607, the island had for more than seventy years been ruled by the Order of the Knights of St John of Jerusalem. From 1530, when Charles V granted the Maltese islands to the order as a free and perpetual feudal territory dependent upon the crown of Sicily, Malta underwent its most glorious period fighting the Turks and fending off the raids of the corsairs. The order, founded at the end of the 11th century by Geoffrey of Bouillon during the First Crusade, was the only one still defending the Holy Sepulchre; many others had by this time dispersed. It remained alone even in the 14th century to guard the coasts from the Turks and pirates who infested the seas. Its internal organization stayed unchanged over the centuries: head of the community was the Grand Master, elected for life and assisted by a capitular council formed of the "pillars" of each of the eight nations represented. Members were noble and celibate, having taken the vow of obedience, poverty, and chastity, and declaring themselves ready to defend the faith.

110

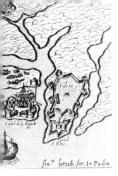

■ Francesco Bertelli, *Malta*, from "Teatro delle città d'Italia con figure intagliate in rame", 1629. A bulwark of defence against the sea attacks of the Turks and the corsairs, Malta was ceded in 1530 to the knightly Order of St John of Jerusalem.

■ Caravaggio, *Portrait of Alof de Wignacourt in Armour and his Page*, c.1608, Musée du Louvre, Paris. This portrait was unusual for the time in its depiction of both knight and page; the Grand Master, however, liked to surround himself with pages, according to courtly fashion.

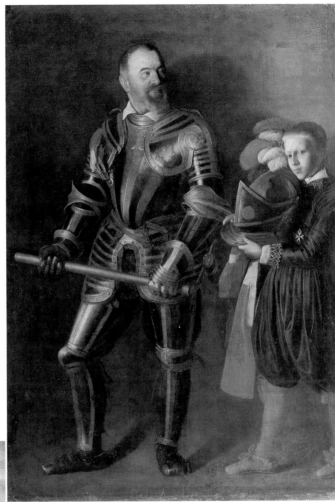

■ Abraham Louis Rodolphe Ducros, *Bird's-eye View of Valletta*, watercolor, Musée Cantonal des Beaux-Arts, Lausanne.

1606-1610

Fame, arrest, and flight from Valletta

Spurred by the desire to obtain the knightly cross, and in hopes of finding a good opportunity to decorate the churches of the order in Valletta, Caravaggio arrived in Malta in July 1607. He may have been assisted by Fra' Ippolito Malaspina, pillar of the order in Naples, and a friend of Ottavio Costa; it was for the latter that he soon painted the *St Jerome* for the Italian chapel in St John's. Caravaggio was preparing for his most beautiful Maltese work, the *Beheading of the Baptist*, when on July 4 he was made a knight: on this painting, in fact, the "fra" precedes the signature, the only one of the painter to have been preserved. Not himself being of noble birth, he was admitted to the knightly ranks by "grace" for his artistic merit. The stay in Malta bore other fruits: a *Sleeping Cupid* (Galleria del Uffizi, Florence), possibly another *St Jerome*, since lost, and the *Annunciation*, now in Nancy. But this good fortune was interrupted by an arrest, either due to a brawl or, more probably, to notification of his homicide and ban from Rome – stains inadmissible for a knight. So he fled once more from the prison of Sant'Angelo and made for Sicily, landing at Syracuse in October. On December 1, he was expelled from the order "tamquam membrum putridum et foetidum".

■ Anonymous, *Cathedral of St John,* c.1640, National Museum of Fine Arts, Valletta. Begun in 1573 by the Maltese architect Gerolamo Cassar and finished in 1577, the cathedral was the conventual church of the Order of the Knights of St John of Jerusalem until 1798.

■ View of Medina, Malta. Situated on a hill, this was the island's capital until it was ceded to the knights. After that, it remained the residence of the archbishop.

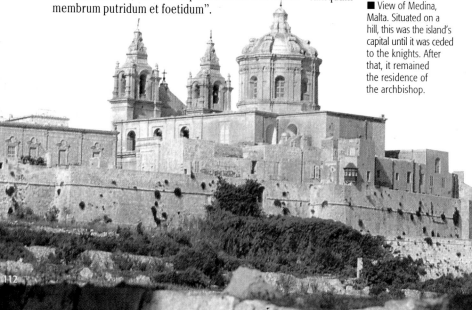

■ Caravaggio, *Crowning with Thorns*, detail, 1602–03, Cassa di Risparmio e Depositi, Prato. The motif of clasped hands aptly reflects the life experiences of the painter himself.

■ Caravaggio, *St Jerome Writing*, detail, 1607, Museum of the Cathedral of St John, Valletta. This was possibly Caravaggio's first work in Malta; in it, the light shapes the forms.

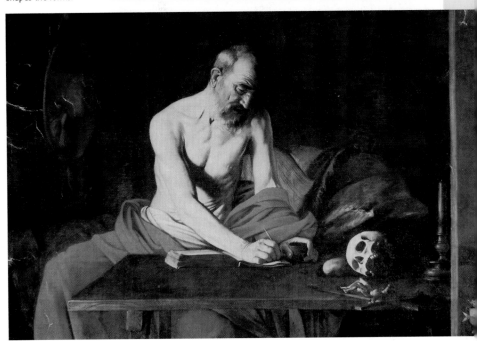

MASTERPIECES

Beheading of the Baptist

Dating from 1608, this is the largest painting produced by Caravaggio in Malta. It was created for the oratory of the knights' cathedral of St John in Valletta, as ordered by Grand Master de Wignacourt.

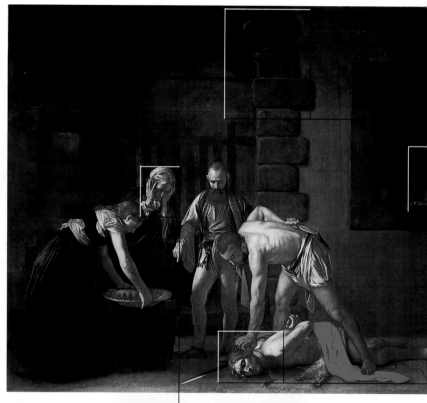

■ The old servant woman is reminiscent of preceding types, such as her counterpart in the *Supper at Emmaus* of Brera. However, she conveys a unique sense of grief, which can be seen as resignation to the inevitable.

■ The characters of the scene have the air of actors passively involved in a drama that is destined to unfold according to a superior will. Although dead, only the Baptist has an expression of a living person, conscious of his sacrifice as the true precursor of Christ on the cross.

■ With this element of architecture, rendered by an artist normally little given to this type of surroundings, Caravaggio shows himself highly expert in using such structures to provide spatial depth and to create a relationship between the figures and the background. The arch corresponds geometrically to the semicircular position of the figures in the foreground.

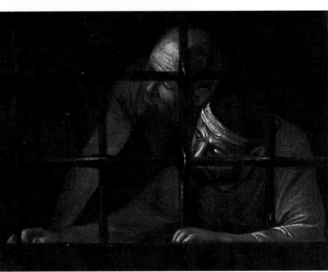

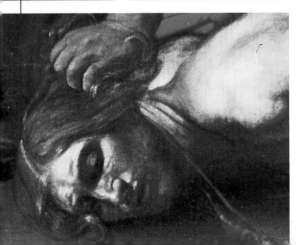

■ In his portrayal of the two gaolers who are watching the scene from behind the grating, Caravaggio respects the oldest representations of the beheading of the Baptist. The light that touches the heads of the two men and brushes the arm of one of them seems to serve to pull them into the foreground.

LIFE AND WORKS

Sicilian interlude

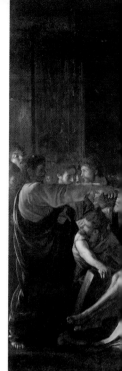

Syracuse was not the usual landing place for travellers from Malta, but it was here that Mario Minniti, Caravaggio's friend from his early days in Rome, lived. He tried to find work for Caravaggio, presenting him to the Senate and obtaining for him the commission of the *Burial of St Lucy* for the church dedicated to the saint. During his short stay, he got to know the archeologist Mirabella, who was to record in a publication of 1613 that he had shown the artist the prisons of the tyrant Dionysus. The following year, he was in Messina, where within eight months he completed four or five paintings, only two of which have survived. The first was commissioned by a wealthy Genoese merchant, Giovanni Battista de Lazzari, for the votive family chapel in the church of the Crusaders. Caravaggio was still a Jerusalem knight and the title was an excellent reference. From this stemmed a second work for the Senate: an *Adoration of the Shepherds* for the church of the Capuchins, which would inaugurate the "poor nativity" genre. The commission earned him about 1000 scudi. He then went to Palermo, where he painted the *Nativity with Saints Francis and Lawrence*. It was now August 1609.

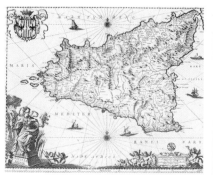

■ Portrait of Cravaggio's Sicilian friend Mario Minitti from *Memorie dei Pittori Messinesi*, C. Grosso Cacopardo, 1821, Messina.

■ Sicily on a map by Willelm Janszoon Blaeu in 1635. In the artist's Sicilian works, one senses the anxiety of the fugitive, forced to conceal his own past.

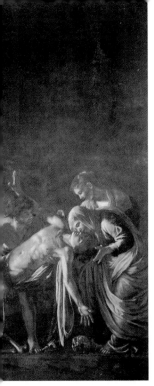

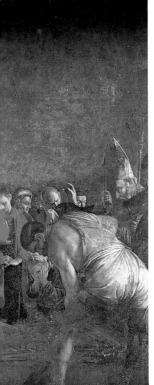

■ Caravaggio's *Raising of Lazarus* (Museo Regionale, Messina) was created for the cross-bearing fathers of Messina in 1609. The event is seen as a real act captured at the very moment it happens.

■ Caravaggio, *Nativity with Saints Francis and Lawrence*, 1609, oratory of the Collegio di San Lorenzo, Palermo. Although representing a return to the conventional, this work shows many elements of the mature Caravaggio.

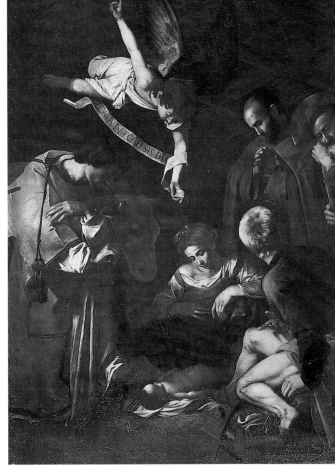

■ Caravaggio, *Burial of St Lucy*, 1608, Chiesa di Santa Lucia, Syracuse. Caravaggio repeats ideas previously tried out, as in the composition, which is reminiscent of the *Death of the Virgin*. He has also already mastered the use of architecture to reduce the dimensions of the human figure.

BACKGROUND

Caravaggio's influence on the painting of southern Italy

■ Massimo Stanzione, *Orpheus Beaten by the Bacchantes*, 1635, Banca Manusardi & C., Milan. Though indebted to Caravaggio, Stanzione owes to Emilian painting his perfect design, still life, and drapery.

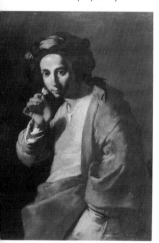

■ Master of the Annunciation of the Shepherds, *Smell*, c.1630, Collezione De Vito, Naples. In this artist's decision to interpret the senses symbolically, there is a hint of Ribera. The naturalistic treatment conveys a feeling of everyday reality.

Southern Italy proved to be a particularly fertile environment for the Caravaggesque revival: the combination of his innovations and local figurative culture produced happy results, taking into consideration the classical currents that stemmed from knowledge of the Bolognese painters. In Naples, where pictorial experience was more markedly based on northern Europe and Spain, and where there was a strong Renaissance legacy, his brand of naturalism quickly took root, finding its distinctive development in artists such as Carracciolo, Stanzione, and the Calabrian Mattia Preti. Simultaneously, in Sicily, Caravaggio's example found logical continuation, as well as innovative expression, based on the works of the island's figurative precursors, associated with Flemish influence, from Antonello da Messina to Polidoro da Caravaggio. Nevertheless, despite acclaim from artists and buyers alike, Caravaggio left behind him, by and large, a series of imitators who were not always capable of recognizing the grandeur and tragic novelty of his works at this time – as compared with the Roman paintings. Most, like the Messina artist Rodriguez, did little more than reproduce superficial features of lighting from his more mature works.

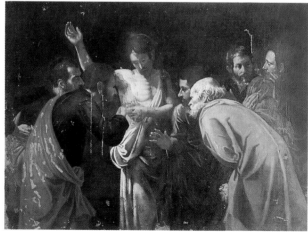

■ Alonso Rodriguez, *The Doubting of St Thomas*, Museo Nazionale, Messina. Rodriguez was one of the more talented followers of Caravaggio.

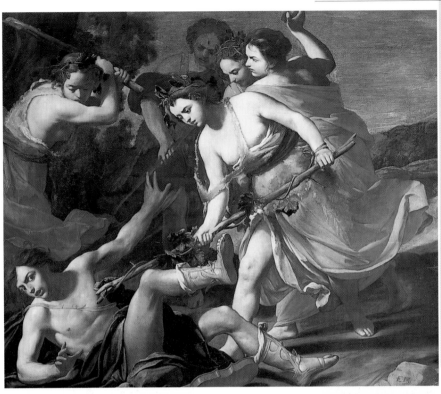

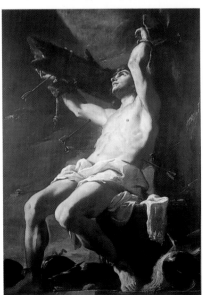

■ Mattia Preti, *St Sebastian*, c.1657, Musei e Gallerie di Capodimonte, Naples. Using his studies of Caravaggio in Rome and, later, in Naples, Preti emphasizes, above all, the importance of light for defining forms and the transverse foreshortening that gives the figures what is by now a Baroque vitality.

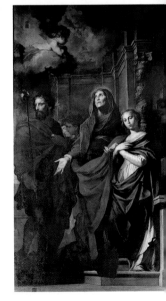

■ Pietro Novelli, *The Nuptials of the Virgin*, 1647, San Matteo, Palermo. The strong lighting that isolates the individual figures is an elegiac touch, derived from Caravaggio's Sicilian works.

Lost and vanished works, mysteries and surprises

After Caravaggio's death, his reputation continued to flourish until about 1630; and virtual oblivion during the 18th century was followed by rediscovery in the 19th century. These fluctuations of taste have helped to spread confusion about his body of work, so that even with the aid of documents and biographies, the various scraps of information do not always tally. Today, alongside a nucleus of absolute authenticity, there is still a small group of works of doubtful attribution. Among the most problematical are those not mentioned in the older literature but which have surfaced as a result of renewed interest in the artist and which, by virtue of technique and iconography, would seem to bear his hallmarks. Then there are copies of originals, and vanished works mentioned by the sources or known through copies. Finally, there are numerous instances of reattribution, for example, *Narcissus*, Galleria Nazionale, Rome, or newly recognized works, such as the recently restored *Capture of Christ*.

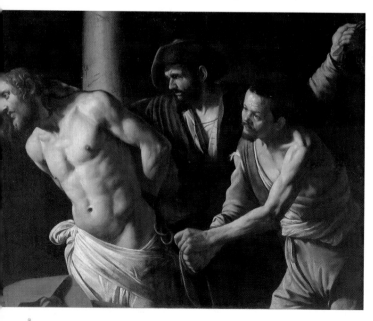

■ Caravaggio, *Christ at the Column*, Musée des Beaux-Arts, Rouen. This work was acquired by the museum in 1955 as the work of Mattia Preti. There are no documents to confirm for certain that it is a Caravaggio original. However, in its favour is the technique used: it is without any preparatory drawing, but with faint marks traced on the ground with the handle of the brush.

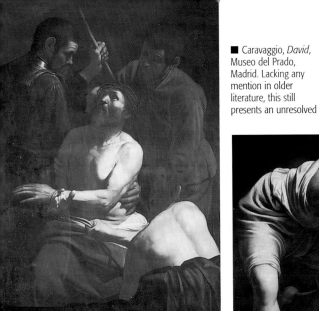

■ Caravaggio, *Capture of Christ*, 1602–03, National Gallery of Ireland, Dublin. Until recently, this was attributed to Gerard van Honthorts, but since restoration in 1993, Caravaggio's hand has been recognized. It is known from certain copies, as that in Odessa.

■ Caravaggio, *David*, Museo del Prado, Madrid. Lacking any mention in older literature, this still presents an unresolved problem in terms of its complex iconography: is it an original or a copy? Is it a copy by Caravaggio or an original by one of his followers?

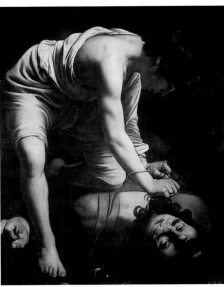

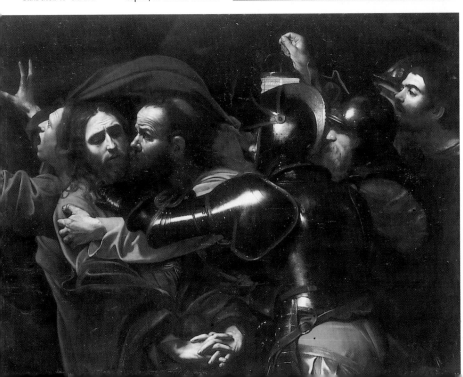

Return to Naples

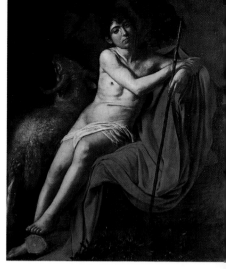

On August 24, 1609, Caravaggio must have been in Naples. Sicily was simply a step in a journey that brought him back to Rome for remission of sentence. It was no longer a matter of escaping but of trying to return to a normal life; yet his Sicilian interlude is recorded as that of someone who has lost both his hope and his wits. His client Nicolò di Giacomo described him as a "twisted brain" and Susinno called him "idiotic and mad", "crazy and quarrelsome", and a "lunatic". Once again, his presence in Naples came to attention because of a violent deed, an assault suffered at the entrance to the Cerriglio inn. At first, it was thought that the painter had been killed, or at least disfigured, according to Baglione and Bellori by the hand of his Maltese "enemy". Yet during the Neapolitan trip, he was more active than ever. The first and most important works were lost in the earthquake of 1805: three paintings commissioned for the church of the Lombards resident in Naples, among them an impressive *Resurrection* in which Christ sprang from the tomb, bypassing the guards. Another prestigious commission, the *Martyrdom of St Ursula*, Caravaggio would leave behind in Naples, having embarked on May 27, 1610 for Genoa.

■ Caravaggio, *St John the Baptist*, 1609–10, Galleria Borghese, Rome. Here, the artist revives a favorite theme of past times, that of the young male nude.

■ Caravaggio (attr.) *The Tooth-drawers*, 1609–10, Galleria Palatina, Florence. Though of uncertain attribution, this painting contains elements that are certainly Caravaggesque, such as the return to a genre subject.

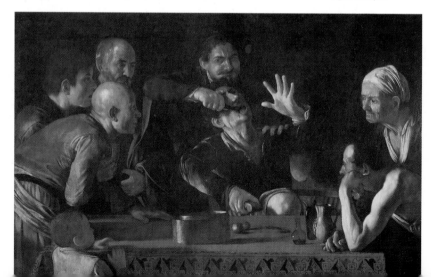

■ Caravaggio, *St John the Baptist at the Spring*, Bonello Collection, Valletta. This could have been the painting that Caravaggio took in the felucca on his return to Rome in 1610. The theme is very typical of him.

■ Caravaggio, *Martyrdom of St Ursula*, 1610, Musei e Gallerie di Capodimonte, Naples. This scene is reduced to essentials, recorded at the termination of the violent event.

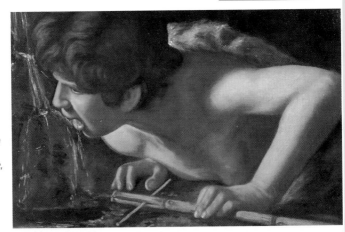

David with the Head of Goliath

Caravaggio's final work, in the Galleria Borghese, dates from 1609–10. Perhaps sent to Cardinal Borghese following the artist's request for a pardon, it is his last representation of the young David killing the giant.

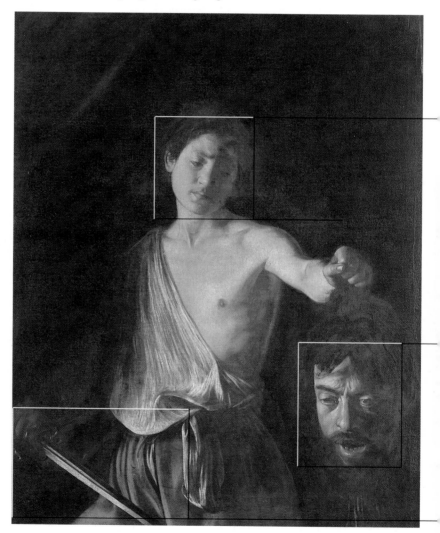

■ The iconography of the painting is wholly personal: David is here no conquering hero or biblical prefiguration of Christ, but has a sad expression that creates a tragic atmosphere. The features of the defeated giant draw sympathy for the victim, who seems to be portrayed as a symbol of the vanity of earthly power.

■ Comparison with another known self-portrait of Caravaggio (from the *Martyrdom of St Matthew*, 1600, San Luigi dei Francesi, Rome) has led to the identification of the artist's own face in that of the decapitated Goliath.

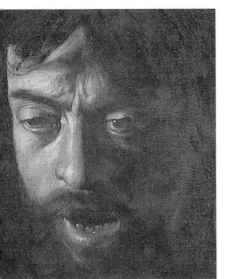

■ According to Belloni, the head of Goliath, dripping blood in the darkness, can be regarded as a crude self-portrait of the painter, perhaps associated with the injury sufffered in Naples shortly after his arrival. The wildly staring face of the victim seems to suggest he still retains a spark of life.

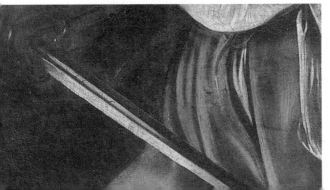

■ The sword, so often present in the artist's work, is now represented in a decidedly simplified manner, as if to demonstrate a certain weariness or boredom with the use of arms.

The triumph of the Emilians

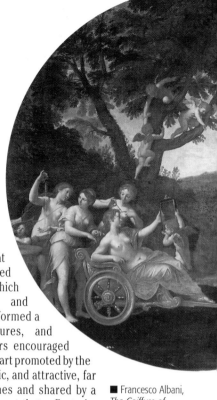

After the successful work of Annibale Carracci in the Farnese Gallery, a troop of Emilians descended on Rome and came to enjoy almost a monopoly in decorative work for villas, churches, and palaces, at least for the first two decades of the new century. They were artists who had chosen an idealized form of painting, a legitimate and "reasonable" representation of nature in that it did not imitate imperfect forms but glorified its nobility. The originators of the group, which included Albani, Reni, Domenichino, and Guercino, as well as the Carracci cousins, formed a school. Once the principles, procedures, and techniques were established, its members encouraged important clients to commission cycles. The art promoted by the Emilians was communicative, propagandistic, and attractive, far removed from the severity of harsher times and shared by a clientele that contributed to its success. An art that reflected a new taste, it aimed to recover visual enjoyment and assert itself as an official language of the Catholic church – thus spelling the doom of the Caravaggesque style.

■ Francesco Albani, *The Coiffure of Venus*, c.1622, Galleria Borghese, Rome. This lyrical landscape contains many classical allusions.

■ Guido Reni, The turbaned girl, detail from the *Martyrdom of St Andrew*, 1608, San Gregorio al Celio, Rome. In his first Roman works, a rational lucidity of pictorial style that harks back to the 16th century is still present. Reni pursues his independent idea of antique beauty and pathos, acknowledging a strong debt to Raphael.

■ *Portrait of Francesco Albani* by Carlo Cesare Malvasia, *Vite de' Pittori bolognesi,* 1678. The Emilian painters were honest and industrious, guaranteed to complete a work without risk to the client.

■ *Portrait of Guido Reni* by Carlo Cesare Malvasia, *Vite de' Pittori bolognesi,* 1678. Reni was one of the most original Bolognese artists in Rome

■ Guercino, *Aurora,* 1621, Casino Ludovisi, Rome. Painted in competition with Reni's *Aurora* in the Palazzo Borghese, Guercino's Baroque goddess seems almost earthly.

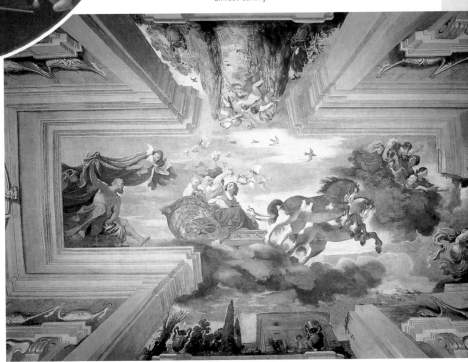

Final days of agony on the beach

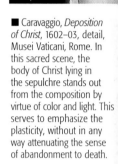

In early July, 1610, Caravaggio departed from Naples and set sail for Rome on a felucca with a few belongings, including perhaps a painting of St John the Baptist (possibly the one in the Borghese or maybe the one in the Maltese collection of Vincenzo Bonello). The official notification of the pardon of Pope Paul V, thanks to the intervention of Cardinal Ferdinando Gonzaga (and to the influence at the papal court of Cardinal Scipione Borghese), had not yet come through, and for that reason it was not prudent for him to land directly on the shores of the Papal State; it was much safer for him to disembark close to the Tuscan garrisons of the Kingdom of Naples, at Monte Argentario. However, the precaution was not sufficient because the painter, on his arrival, was stopped and arrested. According to Bellori, it was a case of mistaken identity and the Spanish guards released him immediately. However, events had now taken a fateful turn. Caravaggio, free but overcome by anxiety and anguish, combed the beach for the boat that had disappeared with his belongings; but hope was almost gone. Some sources say he was struck down by a malignant fever, some that he had never fully recovered from grave injuries he had sustained in Naples, and others that he was assassinated. Whatever the cause, he died within a few days at Port' Ercole and was buried there on July 18,1610.

■ Caravaggio, *Deposition of Christ*, 1602–03, detail, Musei Vaticani, Rome. In this sacred scene, the body of Christ lying in the sepulchre stands out from the composition by virtue of color and light. This serves to emphasize the plasticity, without in any way attenuating the sense of abandonment to death.

■ Beach of Versilia. "Unable to find the felucca again, he was consumed by fury, and in desperation trudged the beach under the burning rays of the sun.... Eventually he reached a place on the beach where he lay down with a fever: and without human aid, in a few days he died wretchedly, just as he had lived." Baglione.

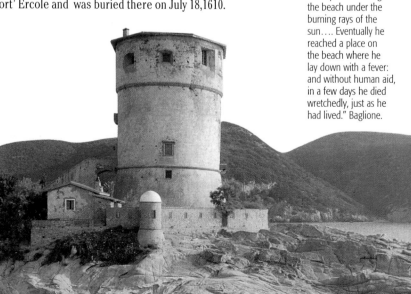

■ Caravaggio, *Christ at the Column*, detail, c.1607, Musée des Beaux-Arts, Rouen. Christ's expression shows that he does not look for help at the moment of his agony, but his face reveals anguish in the knowledge of the offering of his sacrifice.

■ Caravaggio, *Martyrdom of St Matthew,* detail, 1600, San Luigi dei Francesi, Rome. One of the most original features of this scene is that of the altar-boy, who yells in terror at the sight of the assassination. Rigid with fear, he realizes immediately that he can find no escape.

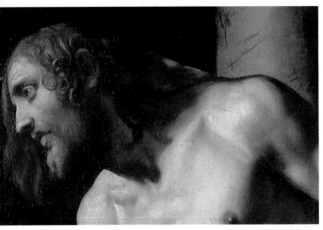

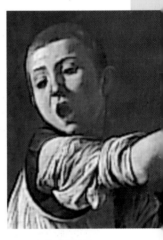

■ Caravaggio, *Death of the Virgin*, detail, c.1600, Musée du Louvre, Paris. Here, the suppressed weeping expresses the grief of an apostle in the face of death.

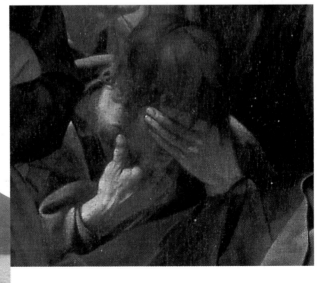

After death: an example to European art

■ Georges de La Tour, *St Joseph the Carpenter*, c.1640, Musée du Louvre, Paris. The artist, determined to convey the scene realistically according to the naturalistic vision of Caravaggio, arranges his version of reality within a formal framework.

Caravaggio was an exceptional figure whose reputation endured after his death. His was a disturbing talent that inspired followers throughout Europe. Among Spanish painters, for example, Il Spagnoletto, active in Naples, although he had not known Caravaggio personally, adopted his particular chromatic range and style of physical representation. These were key elements that he would take home, where they would subsequently be emulated by the great Velázquez. Painters in northern Europe did not always succeed in imitating him without resorting to virtuosity, losing sight of the principal element of his quest for naturalism. Art historians never tired of interpreting, rediscovering, and citing Caravaggio; whether appreciated or criticized, he remained a point of reference. After a century in which interest in the artist was notably reduced, the 19th century saw a a strong revival, evident in copies and in the influence of artists such as Géricault, who copied Caravaggio's Vatican *Deposition of Christ* and showed traces of his luminosity in the *Raft of the Medusa*.

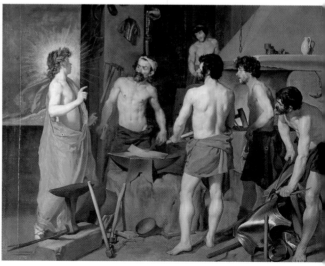

■ Velázquez, *The Forge of Vulcan*, 1630, Museo del Prado, Madrid. The influence of Caravaggio in the treatment of this mythological theme is evident in the everyday surroundings and in the highlighting of the unclothed male bodies by the astute use of chiaroscuro.

■ Gérard von Honthorst, *Happy Reunion*, c.1617, Galleria degli Uffizi, Florence. This artist was very successful in his rendering of the Caravaggesque style, not only in his use of artificial light (here emitted from two hidden sources) but also in his choice of genre scenes.

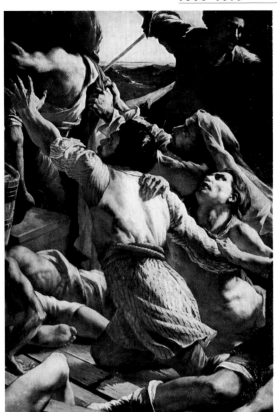

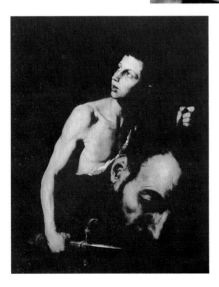

■ Jusepe Ribera, Il "Spagnoletto", *David with the Head of Goliath*, c.1630, Private Collection, Madrid. This is a highly personal interpretation of Caravaggesque naturalism. The figures, illuminated with the immediacy and violence of tenebrism, emerge dramatically from the dark background.

■ Théodore Géricault, *The Raft of the Medusa*, c.1818–19, detail, Musée du Louvre, Paris. The luminous quality of Caravaggio is evident in Géricault's dramatic work, with its strikingly lit figures.

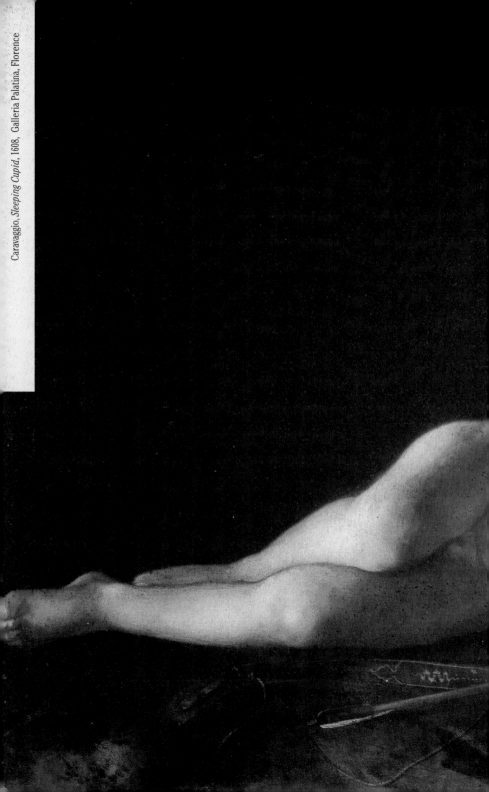

Index

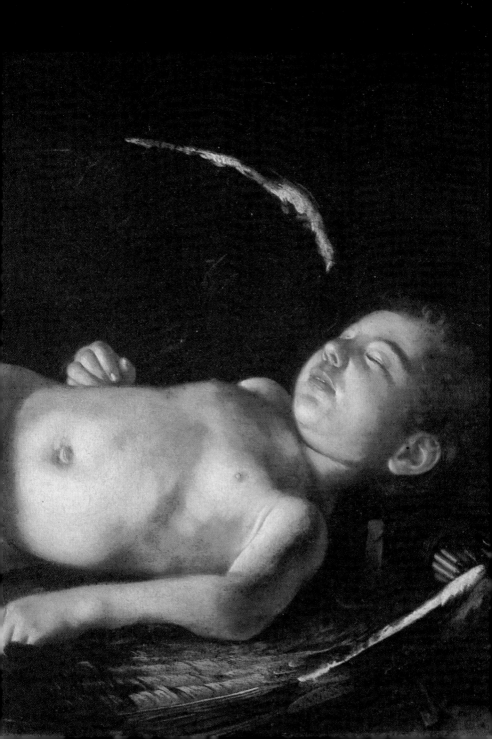

Note

The places listed in this section refer to the current location of Caravaggio's works. Where more than one work is housed in the same place, they are listed in chronological order.

Berlin, Staatliche Museen,
Victorious Cupid, p. 17.

Cremona, Pinacoteca Civica,
St Francis Penitent, p. 55.

Detroit, Institute of Arts,
Martha and Magdalen, p. 57.

Dublin, National Gallery of Ireland,
Capture of Christ, p. 121.

Florence, Galleria degli Uffizi,
Sacrifice of Isaac, p. 10;
Bacchus, p. 43.

Florence, Galleria Palatina,
Portrait of a Knight of Malta, p. 110;
The Tooth-drawers, p. 122;
Sleeping Cupid, pp. 132–33.

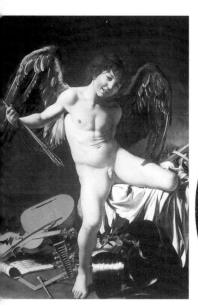

■ Caravaggio, *Victorious Cupid*, 1598–99, Staatliche Museen, Berlin.

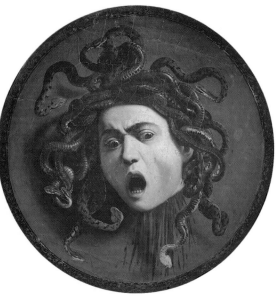

■ Caravaggio, *Head of Medusa*, c.1596–98, Galleria degli Uffizi, Florence.

■ Caravaggio and others, *Fruit and Flowers in Two Carafes*, 1593, Wadsworth Museum, Hartford, Connecticut.

Genoa, Galleria di Palazzo Bianco,
Ecce Homo, p. 79.

Hartford, Connecticut, Wadsworth Atheneum,
The Cardsharps, pp. 6–7, 87;
The Ecstasy of St Francis, p. 55.

Kansas City, Nelson Gallery Atkins Museum,
St John the Baptist, p. 50.

London, National Gallery,
Supper at Emmaus, pp. 93, 98.

Madrid, Thyssen Collection,
St Catherine of Alexandria, p. 57.

Madrid, Museo del Prado,
David, p. 121.

Madrid, Confederación de Cajas de Ahorro,
Sacrifice of Isaac, p. 54.

Messina, Museo Regionale,
Raising of Lazarus, p. 117.

Milan, Pinacoteca Ambrosiana,
Basket of Fruit, pp. 48–49.

■ Caravaggio, *Adoration of the Shepherds*, 1609, Museo Regionale, Messina.

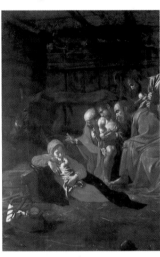

Milan, Pinacoteca di Brera,
Supper at Emmaus, pp. 98–99.

Naples, Chiesa del Pio Monte della Misericordia,
The Seven Works of Mercy, pp. 108–09.

Naples, Musei e Gallerie di Capodimonte,
Flagellation, p. 105;
Martyrdom of St Ursula, p. 123.

New York, Corsini Collection,
Venus and Cupid with Two Satyrs, p. 14.

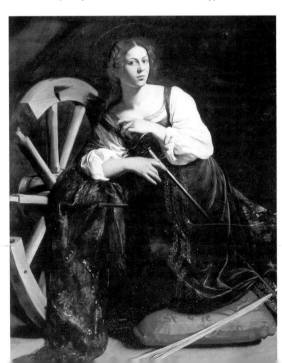

■ Caravaggio, *St Catherine of Alexandria*, 1595–96, Thyssen Collection, Madrid.

■ Pietro Miotte, *View of Naples,* detail of port, engraving, 1648.

Martyrdom of St Matthew, pp. 64–65, 97, 125, 129; *Calling of St Matthew,* pp. 66–67, 97.

New York, Private Collection,
Lute Player, p. 16

New York, The Metropolitan Museum of Art,
Concert of Youths or *Music Concert,* pp. 17, 43.

Palermo, Oratory of Collegio di San Lorenzo,
Nativity with Saints Francis and Lawrence, p. 117.

Paris, Musée du Louvre,
Portrait of Alof de Wignacourt in Armour and His Page, p. 111; *Death of the Virgin,* pp. 58–59, 86, 129.

Prato, Cassa di Risparmio e Depositi,
Crowning with Thorns, pp. 113, 120.

Rome, Chiesa di San Luigi dei Francesi,
St Matthew and the Angel, p. 63;

Rome, Chiesa di Sant'Agostino,
Madonna of the Pilgrims or *Madonna of Loreto,* pp. 82–83.

Rome, Chiesa di Santa Maria del Popolo,
Crucifixion of St Peter, pp. 74– 75, 80; *Conversion of St Paul* pp. 76–77.

Rome, Galleria Borghese,
Sick Little Bacchus, pp. 34, 43; *Mary Magdalen,* p. 40;

■ Rome, Palazzi Vaticani.

Boy with a Basket of Fruit, pp. 42–43; *St Jerome* pp. 88–89; *David with the Head of Goliath*, pp. 100–01; *St John the Baptist*, p. 122.

■ Caravaggio, *St John the Baptist*, 1604–05, Galleria Nazionale di Arte Antica, Rome.

■ Vienna, Kunsthistorisches Museum.

Rome, Galleria Doria Pamphili,
Rest on the Flight into Egypt, pp. 17, 22–23.

Rome, Galleria Nazionale di Arte Antica,
Judith Beheading Holofernes, pp. 56–57.

Rome, Musei Capitolini,
The Fortune Teller, pp. 24–25; *St John the Baptist*, p. 51.

Rome, Musei Vaticani,
The Deposition of Christ, pp. 92–93, 128

Rouen, Musée des Beaux-Arts,
Christ at the Column, pp. 120, 129.

St Petersburg, Hermitage,
Lute Player, p. 16.

Syracuse, Chiesa di Santa Lucia al Sepolcro,
Burial of St Lu cy, p. 117.

Valletta, Museum of the Cathedral of St John,
St Jerome Writing, p. 113; *Beheading of the Baptist*, pp. 114–15.

Valletta, Vincenzo Bonello Collection,
St John the Baptist at the Spring, p. 123.

Vienna, Kunsthistorisches Museum,
Madonna of the Rosary, pp. 106–07.

■ Filippo Vittari, *Bird's-eye View of the City of Messina*, 17th century, formerly Galleria Gasparrini, Rome.

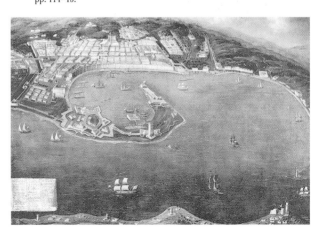

Note

All the names mentioned here are artists, intellectuals, politicians, and businessmen who had some connection with Caravaggio, as well as painters, sculptors, and architects who were contemporaries or active in the same places as Caravaggio.

Aratori, Lucia, mother of Caravaggio, who on the death of her husband supported the large family on her own, p. 10.

Baglione, Giovanni (Rome 1573–c.1644), painter, art historian, and artistic rival to Caravaggio in Rome, he was also the author of *Le vite dei pittori, scultori et architetti*, in which a biography of Caravaggio is included, pp. 11, 70, 95, 122, 128.

Baschenis, Evaristo (Bergamo 1617–77), painter of still lifes that were strongly influenced by Caravaggio, p. 45.

Bellori, Giovan Pietro (Rome 1613–96), antiquarian and art

historian who wrote *Vite de pittori, scultori e architetti moderni* (1672), a work that devoted much space to Caravaggio, pp. 122, 128.

Borromeo, Carlo (Arona 1538–Milan 1584), cardinal archbishop of Milan from 1560, one of leading exponents of the Counter-Reformation, pp. 8, 46, 47.

Borromeo, Federico (Milan 1564–1631), archbishop of Milan from 1595, art collector, and scholar, who founded, among other institutions, the Biblioteca Ambrosiana. He influenced the religious feelings of Caravaggio, pp. 8, 46, 47, 48, 55, 80.

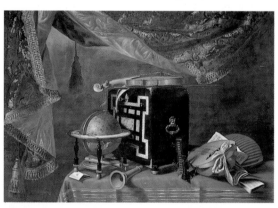

■ Evaristo Baschenis, *Desk, Globe, and Musical Instruments,* c.1650, Gallerie dell'Accademia, Venice.

■ Giovanni Battista Caracciolo, called Il Battistello, *Birth of Mary,* early 17th century, Oratorio dei Nobili della Compagnia di Gesù, Naples.

■ "Velvet" Bruegel, *Hearing*, 1617, Museo del Prado, Madrid.

■ Orazio Gentileschi, *St Christopher Carrying the Christ Child on his Shoulders*, c.1615, Staatliche Museen, Berlin.

Bruegel, Jan the Elder, known as "Velvet"Bruegel (Brussels 1568–Antwerp 1625), painter, second son of Peter the Elder; inherited an inexhaustible inventiveness and great expressive vitality from his father; studied in Rome with the Cavalier d'Arpino, p. 26.

Bruno, Giordano (Nola 1548–Rome 1600), philosopher and writer, judged a heretic by the Roman inquisition and thus condemned to the stake; his person and perhaps his death influenced the thought and art of several contemporaries, including Caravaggio, pp. 38, 63, 77.

Caracciolo, Giovanni Battista, called Il Battistello (Naples 1570–1637), painter who was a follower of Caravaggio even before they both arrived in Naples (1606), pp. 104, 105.

Carracci, family of painters and engravers of the 16th and 17th centuries, who helped to establish the Accademia degli Incamminati, also known as the

Naturale, because it gathered artists devoted to giving painting a new meaning of truth; the most famous of the family was perhaps **Annibale** (Bologna 1560–Rome 1609), a painter and engraver, who was summoned to Rome to decorate the Farnese Palace; he was valued for his naturalistic scenes and elegant landscapes; one of his works was located in the Cerasi Chapel, Santa Maria del Popolo, pp. 35, 36, 53, 74, 84, 126.

Cavaliere d'Arpino, real name Giuseppe Cesari (Arpino 1568–Rome 1640), a famous painter of his time, who carried out imposing decorative works in Rome, Naples, and Frascati between 1592 and 1618; Caravaggio initially trained in his workshop and later became a rival in decorating the Contarelli Chapel in the church of San Luigi dei Francesi, pp. 26, 38, 40, 44, 60, 62.

Colonna, Costanza, wife of Francesco I Sforza, she assumed the marquisate on her husband's death and protected Caravaggio and his family, p. 10.

Colonna, Marzio, friend and protector of Caravaggio, he helped him find accommodation and work in Naples, pp. 104, 106.

Del Monte, cardinal, member of the workshop of St Peter's, he commissioned Caravaggio to

■ Annibale Carracci, *The Dead Christ,* c.1590, Staatsgalerie, Stuttgart.

decorate the church of San Luigi dei Francesi, pp. 60, 78.

Doria, Marcantonio, Genoese prince who welcomed Caravaggio to Genoa, trying to persuade him to decorate with frescos the loggia of his house at Sampierdarena (1605), a job that the painter refused, p. 78.

■ Georges de La Tour, *The Hurdy-gurdy Player*, c.1630–36, Musée des Beaux-Arts, Nantes.

Fontana, Domenico (Melide 1543–Naples 1607), architect who during the papacy of Sixtus V planned and put into practice the urban modernization of Rome, pp. 18, 19, 28, 29, 36.

Foppa, Vincenzo (Brescia c.1427–c.1515), painter, much esteemed by the Sforzas, who worked in Pavia, Genoa, Savona, Milan, and Brescia; his painting had Venetian and Lombard cultural associations, enriched by an attentive study of light, pp. 12, 20.

Gentileschi, Orazio (Pisa 1563–London 1639), painter, friend, and follower of Caravaggio, he interpreted realism with bold and refined contrasts of lighting effects, p. 94–95.

Géricault, Théodore (Rouen 1791–Paris 1824), French painter, engraver, and sculptor who during a journey to Italy in 1816–17 studied Giulio Romano, Caravaggio, Michelangelo, and the Mannerists, mastering the particular use of light which was the characteristic feature of most of his painting, p. 131.

Giovanni da Udine, real name Nanni (Udine 1487–Rome 1504), decorative painter, pupil of Raphael, active in Rome (*Logge*

Vaticane), Florence, and Venice, he was a specialist in "grotesque" painting, appreciated by Caravaggio for its careful representation of nature, p. 44.

Giulio Romano, real name Giulio Lippi (Rome 1499– Mantua 1546), painter and architect, friend of Raphael, built and frescoed at Mantua the Palazzo Te, influencing 16th-century Lombard painting, with his inventions of foreshortening and perspective, p. 20.

Giustiniani, Vincenzo marquis, was among the first clients of Caravaggio in Rome, pp. 16, 17, 61.

■ Andrea Mantegna, *Virgin and Child and Choir of Cherubs*, 1485, Pinacoteca di Brera, Milan.

■ Alessandro Bonvicino, known as Il Moretto, *Holy Family with St John the Baptist*, 1535–40, Museo Poldi Pezzoli, Milan.

by the young Caravaggio in the church of San Francesco Grande in Milan, pp. 12, 13, 46, 86.

Manfredi, Bartolomeo (Ostiano, Cremona c.1587– Rome 1620), painter and follower of Caravaggio who spread his style throughout Europe, p. 94.

Mantegna, Andrea (Isola di Carturo, Padua 1431– Mantua 1506), painter and engraver, painted works of great dramatic power which deeply influenced his contemporaries and the artists of successive generations with his modelling of figures and his plastic and chromatic effects, p. 20.

Melandroni, Fillide, model of Caravaggio who inspired the faces of a number of his famous female characters, p. 57.

Merisi, Fermo (?–1576), architect, father of Caaravaggio, who was *magister* with Francesco I Sforza, p. 10.

Moretto, Alessandro Bonvicino, known as Il (Brescia 1498–c.1554), painter of the "Lombard school", inspirer of the young Caravaggio, pp. 13, 20.

Honthorst, Gérard (Gerrit) van, known in Italy as Gherardo delle Notti (Utrecht 1590–1656), Dutch painter, was influenced by Caravaggio's naturalism, painting night scenes, sacred genre pictures and interiors, p. 131.

La Tour, Georges de (Vic-sur-Seille 1593–Lunéville 1652), French painter, whose artistic upbringing was influenced by Caravaggio and the 17th-century advocates of naturalism, alongside whom he probably worked during a youthful journey to Italy, p. 130.

Leonardo da Vinci (Vinci, Florence 1452–Amboise 1519), painter, sculptor, architect, engineer, and writer, he conceived science as a complement to artistic endeavor. His *Virgin of the Rocks* was probably admired

Giovan Battista Moroni, *Portrait of a Youth*, before 1550, Pinacoteca Nazionale, Siena.

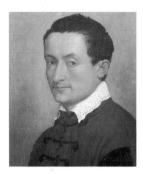

Moroni, Giovan Battista (Albino, Bergamo c.1529– Bergamo 1578), Lombard painter, active above all in Bergamo; his work, close to the Venetian art of Titian, was certainly known by Caravaggio during his formative years, p. 20.

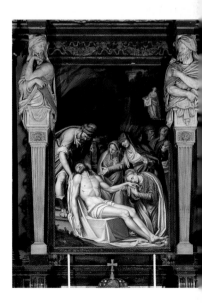

■ Simone Peterzano, *Entombment*, 1584, Chiesa di San Fedele, Milan.

■ Giovan Gerolamo Savoldo, *SS Anthony Abbot and Paul Hermit*, c.1520, Gallerie dell'Accademia, Venice.

■ Raffaellino da Reggio, *Joseph and the Angel*, c.1577, San Silvestro al Quirinale, Rome.

he interpreted somewhat sentimentally the ideals of the Counter Reformation. Summoned to Lombardy by Federico Borromeo, he helped to popularize, among other things, hagiographic subjects, p. 30.

Peterzano, Simone (Bergamo, active 1573–96), painter probably trained in Venice, he was Caravaggio's teacher from 1584, pp. 14, 15.

Philip II, known as the Prudent (1527–98), firstborn of Charles V, he was king of Spain, Naples and Sicily, Portugal, and duke of Milan; he emerged as the champion of Catholic orthodoxy in all the wars of religion waged during the 16th century, p. 9.

Preti, Mattia, known as the Cavaliere Calabrese (Taverna, Catanzaro 1613–Valletta 1699), painter influenced by Caravaggio, active in Rome, Naples, and Modena, in 1661 he moved to Malta where he became official painter to the Order of Knights

and produced monumental decorative cycles and many canvases, pp. 118, 119, 120.

Radulovic, Nicolò, merchant of Ragusa who was probably one of Caravaggio's first clients in Naples, when the painter arrived there in 1606, pp. 104, 106.

Raffaellino da Reggio, real name Raffaellino Motta (Codemondo, Reggio Emilia 1550–Rome 1578), Mannerist painter allied to the Zuccari, who worked in Rome at the end of the 16th century, p. 31.

Reni, Guido (Bologna 1575–1642), painter linked to the Accademia dei Carracci, who studied Raphael and Caravaggio, pp. 69, 75, 126–27.

Rubens, Peter Paul (Siegen, Westphalia 1577–Antwerp 1640), Flemish painter who travelled in in Italy from 1600 to 1608; his subsequent works showed the influence of Caravaggio in their

Muziano, Girolamo (Aquafredda, Brescia 1528–Rome 1592), painter and engraver, initially linked to the Lombard school of Romanino and Moretto, and to Venetian painting, who was then influenced, in Rome, by Michelangelo's Mannerism; still in Rome he was commissioned, before Caravaggio, to decorate San Luigi dei Francesi, p. 62.

Nebbia, Cesare (Orvieto 1534–1614), painter, pupil of Girolamo Muziano, who did large decorative works in Rome. An exponent of Mannerism,

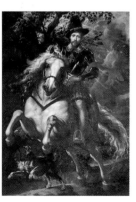

■ Peter Paul Rubens, *Equestrian Portrait of Marquis Giovanni Carlo Doria*, c.1606, Musei e Gallerie di Capodimonte, Naples.

■ Massimo Stanzione, *Saint Agnes in Prison,* c.1630, Palazzo Vecchio, Florence.

use of luminous effects and chiaroscuro, pp. 72, 73.

Salviati, Cecchino, Francesco de' Rossi, (Florence 1510–Rome 1563), prominent Mannerist painter, active in Rome in the middle of the 16th century, then in Florence, Venice (working with Giovanni da Udine), Mantua, Verona, and Parma, p. 31.

Savoldo, Giovan Gerolamo (Brescia c.1480–Venice c.1550), painter, influenced by Giorgione and Titian, exponent of the Lombard school and considered to have been one of the principal inspirers of Caravaggio's luminism, pp. 20, 21.

Sforza, Francesco I, marquis of Caravaggio (?–1583), protector and employer of Caravaggio's father, p. 10.

Sixtus V (Grottammare 1520–Rome 1590), secular name Felice Peretti, he became pope in 1585; his name is linked with important financial reforms and with the construction and reconstruction of notable public buildings in Rome, pp. 28, 29, 36, 46.

Stanzione, Massimo (Orta di Atella, Caserta 1585–Naples 1656), painter, follower of Caravaggesque realism, who brought a change to 17th-century Neapolitan painting, pp. 118, 119.

Titian, Tiziano Vecellio (Pieve di Cadore 1490?– Venice 1576), among the greatest of 16th-century Venetian painters, he influenced the Lombard painters and Caravaggio, pp.13, 15.

Valentin or Jean de Boulogne, also known as Moses V (Coullommiers 1594–Rome 1632), French painter, pupil in Rome of Bartolomeo Manfredi, through whom he was influenced by Caravaggio; he is therefore regarded as one of the earliest Caravaggisti. He had a

■ Tiziano Vecellio, *Self-portrait,* 1562, Staatliche Museen, Berlin.

preference for genre painting and depicted worldly scenes with Roman backgrounds, populated with drinkers, gypsies, gamblers, and soldiers, p. 40.

Wignacourt, Alof de, Grand Master of the Order of the Knights of Malta, painted by Caravaggio while he stayed in Malta, he also commissioned him to paint the *Beheading of the Baptist* for the oratory of the church of the Knights of St John in Valletta, pp. 110, 111, 114.

■ Valentin de Boulogne, *St John the Baptist,* c.1628–30, Santa Maria in Via, Camerino.

A DK PUBLISHING BOOK
Visit us on the World Wide Web at http://www.dk.com

TRANSLATOR
John Gilbert

DESIGN ASSISTANCE
Joanne Mitchell

MANAGING EDITOR
Anna Kruger

Series of monographs
edited by Stefano Peccatori and Stefano Zuffi

Text by Rosa Giorgi

PICTURE SOURCES
Archivio Electa
Elemond Editori Associati wishes to thank all those museums and
photographic libraries who have kindly supplied pictures, and would be pleased
to hear from copyright holders in the event of uncredited picture sources.

Project created in conjunction with
La Biblioteca editrice s.r.l., Milan

First published in the United States in 1999 by DK Publishing Inc.
95 Madison Avenue, New York, New York 10016

ISBN 0-7894-4138-1

Library of Congress Catalog Card Number: 98-86749

First published in Great Britain in 1999
by Dorling Kindersley Limited,
9 Henrietta Street, London WC2E 8PS

A CIP catalogue record of this book is available from the British Library.

ISBN 0751307246

2 4 6 8 10 9 7 5 3 1

© 1998 Leonardo Arte s.r.l., Milan
Elemond Editori Associati
All rights reserved

Printed by Elemond s.p.a. at Martellago (Venice)